100 GREATEST PHOTOGRAPHS

TO EVER APPEAR IN ARIZONA HIGHWAYS MAGAZINE

ARIZONA HIGHWAYS

Edited by: JEFF KIDA AND ROBERT STIEVE
Text: KATHY M. RITCHIE
Photographs: ARIZONA HIGHWAYS CONTRIBUTORS
Design: BARBARA GLYNN DENNEY
Editorial Assistants: NIKKI KIMBEL AND MOLLY J. SMITH

Library of Congress Control Number: 2013935435
ISBN 978-0-9887875-2-0
First printing, 2013. Second printing, 2014. Third printing, 2014. Printed in China.

ARIZONA
HIGHWAYS

Published by the Book Division of *Arizona Highways* magazine, a monthly publication of the Arizona Department of Transportation
2039 W. Lewis Avenue, Phoenix, Arizona 85009.
Telephone: 602-712-2200
Website: www.arizonahighways.com

Publisher: WIN HOLDEN
Editor: ROBERT STIEVE
Managing Editor/Books: KELLY VAUGHN KRAMER
Associate Editor: NOAH AUSTIN
Creative Director: BARBARA GLYNN DENNEY
Art Director: KEITH WHITNEY
Design Production Assistant: DIANA BENZEL-RICE
Photography Editor: JEFF KIDA
Production Director: MICHAEL BIANCHI
Production Coordinator: ANNETTE PHARES

THIS ISN'T SOMETHING WE DID LIGHTLY. It didn't happen overnight. And not everyone on our staff agreed with the final cut. But we did it. We took a stack of more than a thousand issues, pored over tens of thousands of images, and put together a portfolio of the 100 best photographs to ever appear in *Arizona Highways*. It's a simple concept, but nothing about it was easy.

The idea came from a conversation I had with a young woman from Dallas. I know she was young because I asked her. She was 27, and she was criticizing our photography, saying it was so much better in the '40s and '50s. That's when I asked about her age. Turns out, her grandmother had a basement full of old copies of *Arizona Highways*, and the granddaughter remembered looking through them as a kid. She said she was a photographer, so I listened, I let her vent, and when we hung up, I headed across the hallway to look at some back issues. I was curious.

It didn't take long to realize the 27-year-old was right. We did publish some incredible images in the early decades of this magazine, and many of them were shot by heavyweights such as Ansel Adams, Edward Curtis and Laura Gilpin. Nevertheless, I wasn't convinced that the overall body of work in the '40s and '50s was significantly better than what we're doing today. In my view, there was no golden era, just decades and decades of spectacular photography. And that got me thinking: *I wonder how hard it would be to condense nearly 88 years of photography into the 100 best images of all time*. It wasn't easy, but we did it.

The first round took several months, but we managed to cut thousands of photos down to around 300 without anybody storming out of the building. We had one criterion as we looked at each image: Is this one of the 100 best photos ever published in the magazine? It seems like an obvious filter, but the staff was all over the place. Some thought we should have a mix of portraits and landscapes. Some wanted geographical balance. Some wanted more flowers, and maybe some birds. But along the way, I kept reminding them: "It's the 100 best. Period. If that turns out to be 100 shots of the Grand Canyon by Ansel Adams, so be it. That's the portfolio."

We had a plan, but we were a long way from being done.

Round 2, the cut from 300 to 125, was a scrum, and staffers started getting territorial with their picks. And then the real bloodbath began. Trying to eliminate those last 25 photos ... it was like sending 25 loved ones off to the gallows. It wasn't easy, but one by one, we kept cutting until we got it down to 100. They're presented here chronologically, based on the dates they appeared in the magazine — not the dates they were made. Although the final cut is purely subjective, we're comfortable with our collection, and we hope you like it, too.

Robert Stieve
Editor in Chief

CONTENTS

FOREWORD

I LOVED THE RANCH WHERE I SPENT SO MUCH TIME AS A CHILD. It is probably not Arizona's most beautiful spot, but it meant so much to me. I treasured it.

At night, my brother and I would look up — there wasn't any light from Phoenix or Tucson — and we would see stars and planets and things in the sky that just seemed so close we could reach out and touch them. No one can imagine a desert sky like that. Pure magic.

Arizona is a beautiful state. We have marvels that anyone from anywhere in the world would want to see. Nothing equates to the Grand Canyon. Then, there's Monument Valley. And I always liked going to the Hopi mesas and Canyon de Chelly. I'd go there and think, *We have places no one else has. Magical places with magical things.* For nearly 90 years, *Arizona Highways* has been sharing that magic with people the world over. Through its iconic photographs, the magazine has shown readers in all 50 states and more than 100 countries that Arizona offers magnificent desert skies, beautiful landscapes ... and so much more. In many ways, *Arizona Highways* put Arizona on the map.

Esther Henderson, Edward Curtis, Josef Muench, Ansel Adams and even Barry Goldwater explored the state's Native people and their homes, creating portrait and landscape images that have endured for decades. So many of those photographs appear in the pages of this book, and it is plain to see why they stand out among the best of the best to have ever been published in *Arizona Highways*.

The same goes for the other photographs included here. They capture Arizona's geographic diversity — from the snowcapped San Francisco Peaks and the pine forests of Northern Arizona to the Sonoran Desert and the grasslands of Southern Arizona — and celebrate the state's people and cultures.

These photographs create a lasting impression, a storybook of sorts. They are, and long will be, a visual history of the 48th state, a tribute to my home and the land I love so much.

Sandra Day O'Connor
Washington, D.C., March 2013

ARIZONA HIGHWAYS IS MUCH LIKE THAT OTHER PICTURE MAGAZINE — *National Geographic.* No one ever throws a copy away, and basements across America contain revered stacks of the magazines. It's not just because the pictures are interesting or always great — it's the subject matter.

Just as *Geographic* has defined itself through intriguing content — from indigenous people to serious revelations of developing science — the pages of *Arizona Highways* have long been a spectacular resting place for the stunning beauty of Arizona.

My first trip to Arizona was during a family vacation, when we traveled to Flagstaff to visit my parents' best friends, the Ardreys. The historical fabric of Arizona, especially Northern Arizona University, includes the name of Dr. Eldon Ardrey. In fact, Dr. Ardrey, who led the university choir in the sunrise service on the South Rim of the Grand Canyon for NBC radio, introduced my family to *Arizona Highways.*

The magazine came to my parents for quite some time, and it's been delivered to my own home for many years now. For nearly nine decades, the magazine has grown and progressed, and the excellence and beauty that have graced its pages have never diminished. The magazine treats Arizona's ancient people and cultures with contemporary respect, and that's due in large part to its photographic contributors.

The photographers helped establish a cornerstone of the American West, for no other single publication has created such a repository of lasting images. And the artistry has even spanned generations. Take, for example, the Muench family. The surname keeps reappearing in the pages of *Arizona Highways* and in this book, from Josef to David to Marc. The same is true for other talented photographers whose palettes were of Kodak, Graflex and Nikon.

But their roads were paved by other greats. First came the glass plates of Edward Curtis, and then, in 1937, Ansel Adams — accompanied by Georgia O'Keeffe and David McAlpin — motored through Arizona. Adams was among those photographers who were as intrigued by people as they were by landscapes. Over the years, *Arizona Highways* has published revealing photographs of Arizonans — particularly the Navajo and Hopi — along with its spectacular vistas.

Those famed photographers are well-matched to their modern counterparts, who are also well-known to *Highways'* readers: Jerry Jacka, Randy Prentice, Jack Dykinga, George Stocking, J. Peter Mortimer, Tom Bean, Jeff Kida and Gary Ladd, to name a few. All of them are respected artists in the American photographic community, but they're best known for their work in *Arizona Highways* — a most respected place to find an individual's portfolio.

That explains why one of Dr. Ardrey's proudest moments was when one of his own photographs was published in the magazine. You won't find it in this book, but you will find Curtis, Adams, Dykinga and more — a tribute to *Arizona Highways'* stature as a fine photographic publication.

No other magazine of the American West enjoys the same reputation, or renews itself with each passing year as both new and veteran photographers rediscover the uniqueness of Arizona.

Rich Clarkson
Denver, Colorado, March 2013

Rich Clarkson is the former director of photography for *National Geographic* and a longtime contributing photographer to *Sports Illustrated.* He is the owner of Colorado-based Rich Clarkson and Associates, a creative services company.

MARCH 1946
4x5" FILM
MONUMENT VALLEY

It's the composition of this photograph that impresses us most. One of the things Ansel Adams brought to his photographs was a heavy emphasis on foregrounds in relationship to background elements. In fact, he was very well known for that, and that influenced scads of photographers. Here, he used the rock formation as an anchor to lead the viewer's eye toward the mitten in the upper right of the frame. Regarding composition, Ansel once said, "A good photograph is knowing where to stand."

"Both the grand and the intimate aspects of nature can be revealed in the expressive photograph. Both can stir enduring affirmations and discoveries, and can surely help the spectator in his search for identification with the vast world of natural beauty and wonder surrounding him."

— ANSEL ADAMS

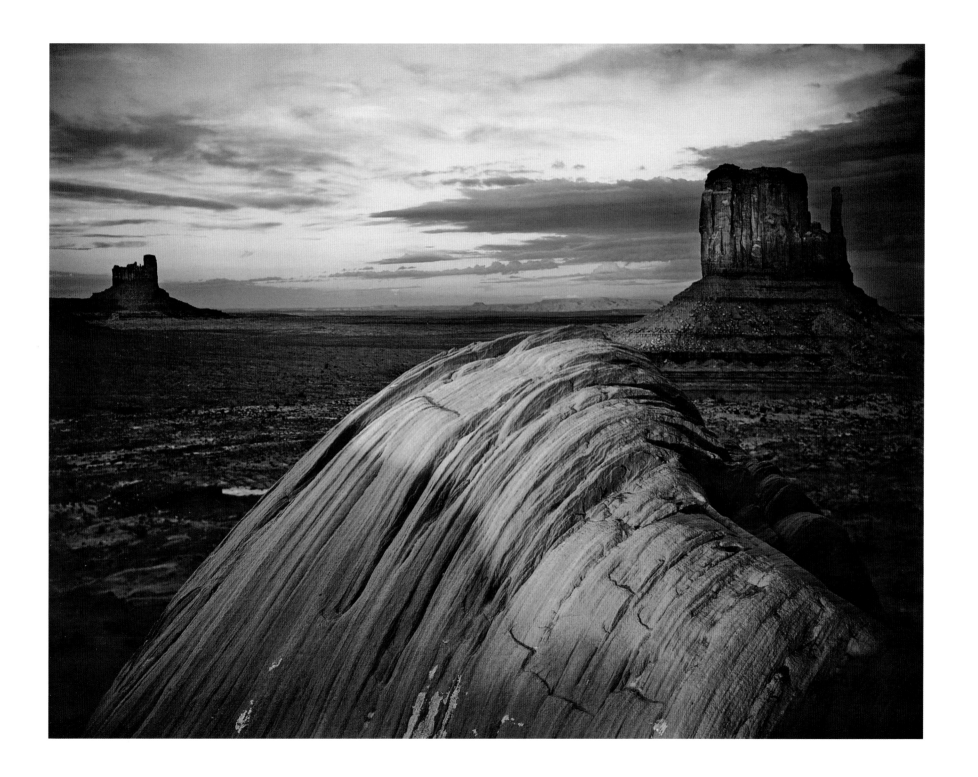

BARRY M. GOLDWATER

DECEMBER 1946
4x5" FILM
NAVAJO INDIAN RESERVATION

Relationships and access often are key to making a powerful image such as this one. The editor at the time selected this shot — *Navajo Herding Sheep in the Snow*. Barry Goldwater had a special relationship with the Navajo people, and Editor Raymond Carlson knew that. Barry made this image in January 1946, and the photo ran on the December 1946 cover of *Arizona Highways*. This is a moment frozen in time. Everything about it says "history" — both for the Navajos and for the magazine.

"To photograph and record Arizona and its people — particularly its early settlers — was a project [to which] I could willingly devote my life, leaving an indexed library of negatives and prints to those who will follow. As I look back, it has been a most enriching experience: Five thousand negatives, hour on hour in the dim light of a darkroom, thousands of miles traveling my own state and then thousands more across the world in war and peace — exposing, loading, unloading, developing and printing."

— BARRY M. GOLDWATER

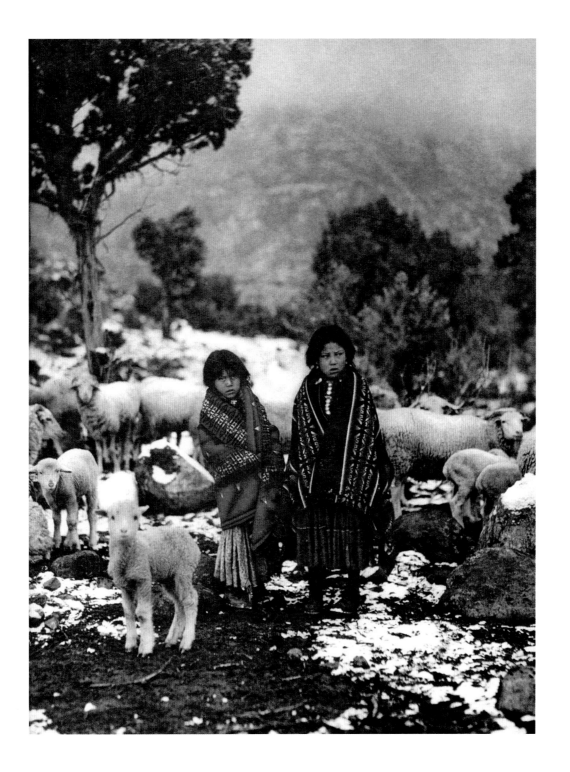

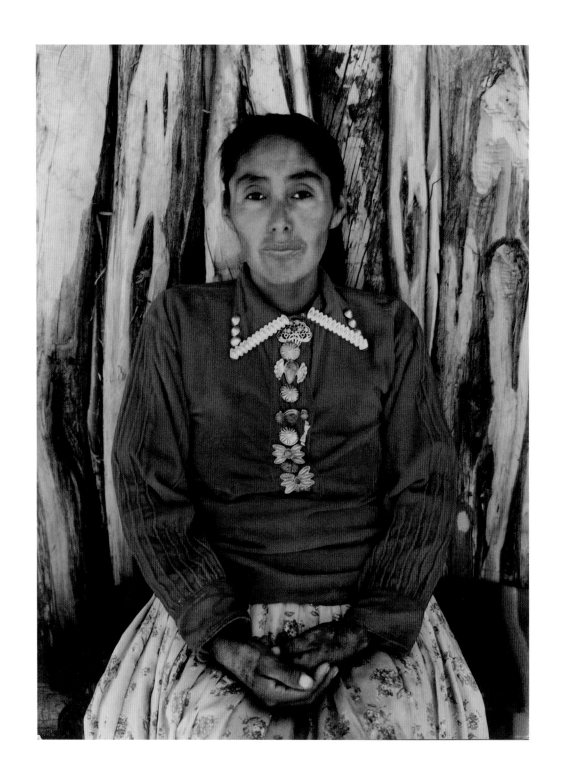

ANSEL ADAMS

DECEMBER 1953
4x5" FILM
NAVAJO INDIAN RESERVATION

Ansel Adams was known for his landscapes, and it was rare for him to photograph people. That's part of what makes this image of Louise Dale so interesting. There's a wonderful symmetry to the subject's posture, and a balance between her blue skirt and red shirt. If you look at her hands, they seem to be working hands, yet her face ... there's a wonderful serenity to her face.

"Some photographers take reality and impose the domination of their own thought and spirit. Others come before reality, more tenderly, and a photograph to them is an instrument of love and revelation."

— ANSEL ADAMS

ALLEN REED

APRIL 1956
MEDIUM-FORMAT FILM
MONUMENT VALLEY

Although this scene was posed, there's something dignified about the resulting image. The symmetry and composition of this photograph are well crafted. There are so many dimensions, as well — the woman on the horse and another horse below. The woman, of course, is framed in the arch. Some photographers during this era tended to stage their shoots because cameras were cumbersome and film was slow. It was more difficult to freeze motion in the 1950s.

"Monument Valley is a blend of a beautiful land and a beautiful people. As hydrogen and oxygen combine to make water, so does this land of fantastic monuments, mesas, arches, distance, sand and sage blend with the sheep, the hogans, the ceremonies and the colorful ways of the Navajo to complete the equation — the formula that is Monument Valley. One can hardly visit Monument Valley without being conscious of both elements simultaneously: the people and the land, fused as one, wedded to live in apparent harmony."

— ALLEN REED, *Arizona Highways*, April 1956

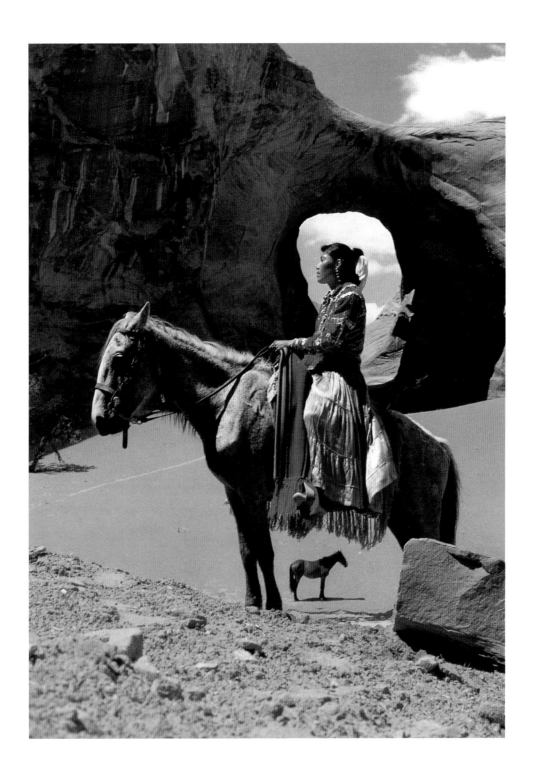

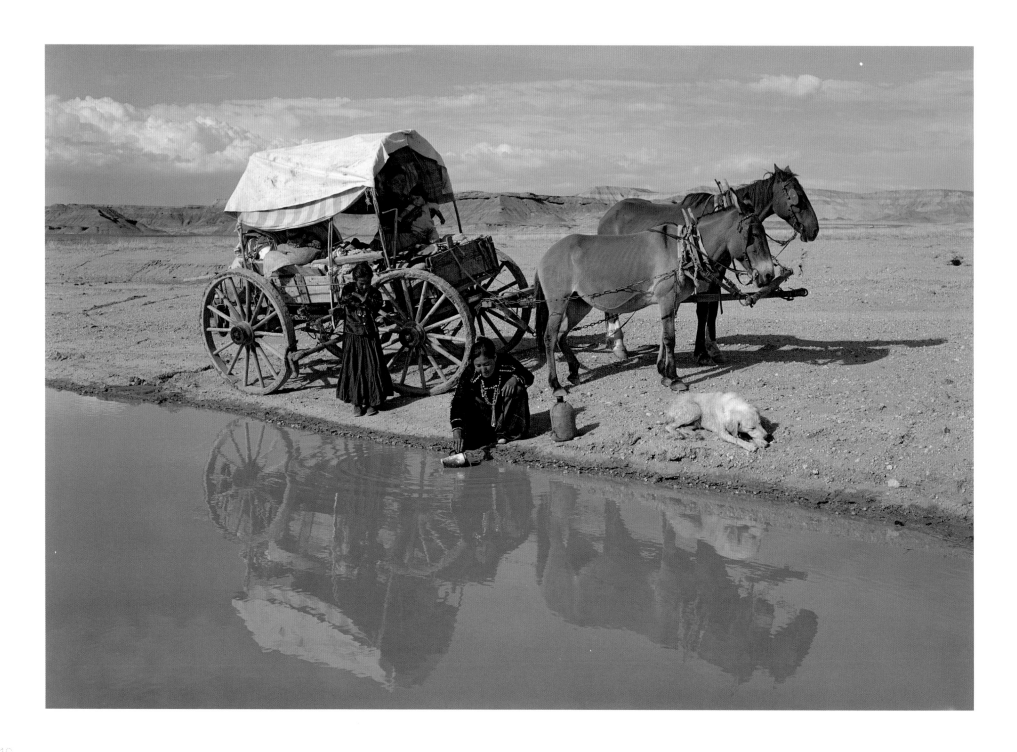

RAY MANLEY

MARCH 1957
5x7" FILM
NEAR TUBA CITY

For this photograph, Ray Manley kept his distance, and in doing so, he allowed the Navajos their privacy. But he also captured the spirit of the family. This is history. It's 1957, but it feels so much earlier than that — this photograph could have been made 100 years earlier. It's really a slice of life — if you look inside the wagon, you can see people tending to their children. The composition is clean, and there's a nice reflection. This is a very relaxed photo. Nothing is hurried. The dog is sleeping, and everything is quiet.

"I have photographed nearly every place in the world since first visiting Navajoland. Eight photographic coverages circling the earth have exposed me to most of its natural wonders, and those made by man. To this day, nothing compares with the photogenic challenges of Navajoland and its wonderful people."

— RAY MANLEY, *Ray Manley's Navajoland: A Portfolio of Navajo Life During the 1940s and 1950s*

JOSEF MUENCH

AUGUST 1957
4x5" FILM
MONUMENT VALLEY

The beauty and simplicity of this image were most striking. There's movement in the subject's right hand, and her expression is one of attentiveness, as though she's part of a conversation. Josef Muench captured a beautiful moment. Everything about the photograph is elegant.

"The Indian, whatever his tribe, is an American and resents being considered a museum piece or a quaint character. Would you walk into a neighbor's yard and shoot him, or enter his home or church without permission? To me, the Navajos, who outnumber all the other Indian groups, belong to the scenery, enriching it and giving it new meaning."

— JOSEF MUENCH, *Arizona Highways*, October 1952

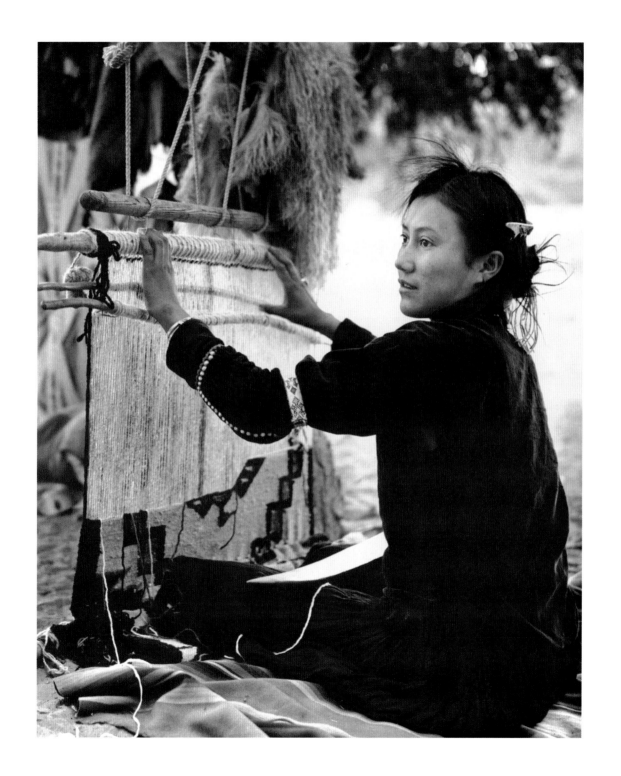

JOSEF MUENCH

JULY 1960
4x5" FILM
MONUMENT VALLEY

Josef Muench made this image using Kodachrome. That, combined with shooting in soft, overcast light, resulted in a painterly feel. You can see the clouds — the soft light coming from behind — and there are no deep shadows. Muench had rapport with the Navajos, a reverence and respect for the people.

"Perhaps the most nearly perfect setting for the Navajos is Monument Valley. The red sandstone monuments are spaced across its desert and the Indian on his pony has room enough for the free-swinging lope they both love. Scenes taken around campfires, beside the hogan, take on a vividness that, even years later, can bring back the odor of burning piñon and the sound of lambs calling for their mothers. Sand dunes lift in salmon colored patterns for pictures that speak of desolate lands and the courage of its inhabitants. The red of Navajo rugs on the loom blends with the cliffs. Skies are a pageant of moving forms above the widespread drama of the land."

— JOSEF MUENCH, *Arizona Highways*, October 1952

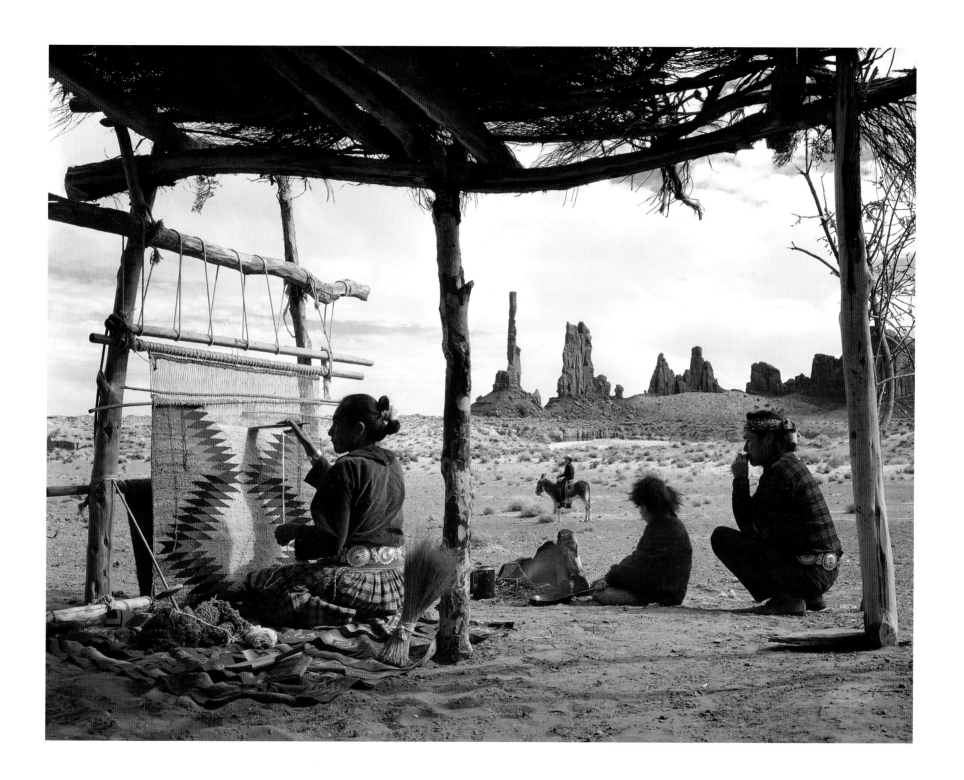

ESTHER HENDERSON

JANUARY 1968
4x5" FILM
PRESCOTT

Successful images can sometimes transport their viewers to another place and time. Esther Henderson made this photograph on Pleasant Street in Prescott, and, according to her, it reminded her of growing up in the Midwest. Indeed, it's reminiscent of something Norman Rockwell would have painted. It feels like a slice of Americana. It has a wonderfully idyllic sense to it.

"One day, in New York, [Esther Henderson] decided to choose a profession less strenuous and more secure than dancing, [so, she] picked photography, took a course in it, and headed west. She thought she would like San Antonio, Texas, but it rained for a week, and so, she started for the Pacific coast. A happy train-chance took her through Tucson, where she fell in love both with the place and Arizona sunshine on a stopover, and has remained there since."

— RAYMOND CARLSON, *Arizona Highways*, June 1943

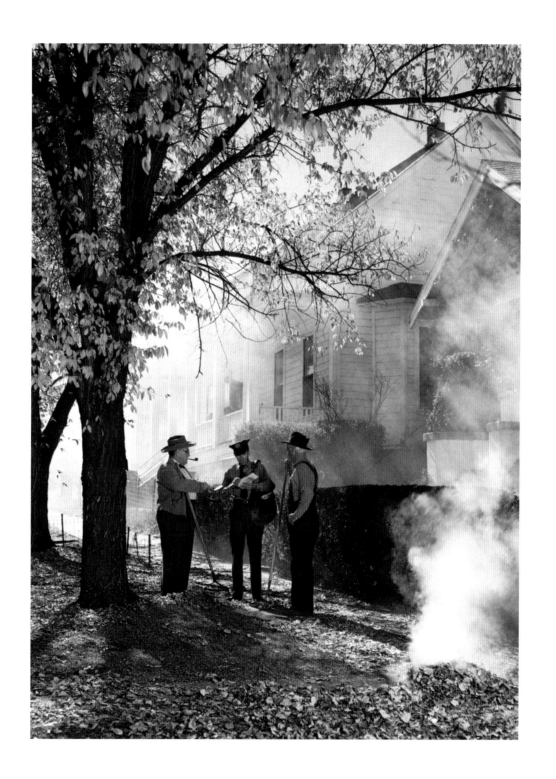

DAVID MUENCH

JULY 1968
4x5" FILM
LAKE MEAD

A change in perspective can make all the difference in a great photograph, as was the case with this image. David Muench positioned himself on the ground, at eye level with the flowers. Using a wide-angle lens, he was able to carry the depth of field from the foreground — where the flowers are — all the way to the distant mountains. Ansel Adams started using foregrounds very forcefully, and Muench took it a step further by making them dominate a scene.

"I was pushing the envelope a little. I was getting low and trying to make the flowers appear glorious against the water — they were larger than life."

— DAVID MUENCH

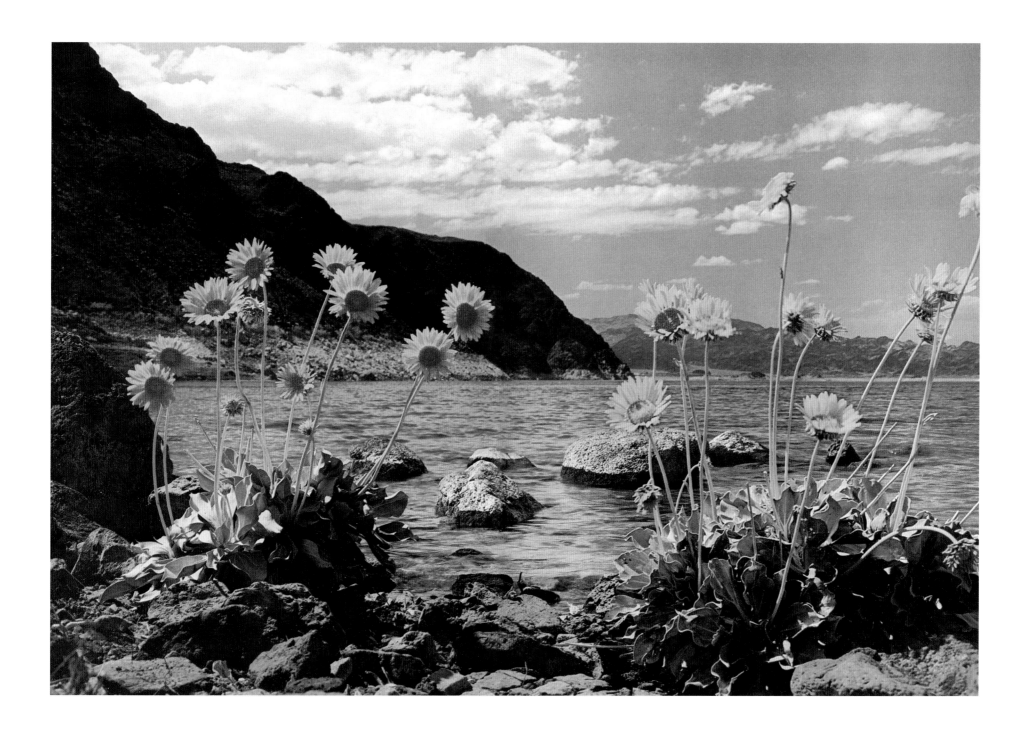

BARRY M. GOLDWATER

AUGUST 1968
35 MM FILM
NEAR WINDOW ROCK

This photograph is titled *The Navajo*. The subject has an amazing, dignified face. His cheekbones are pronounced; his head is slightly lifted. The light brings out those features, that strong nose and chin. Barry Goldwater also shot this photograph from low to high, which gives his subject greater stature.

"Emerson has written that beauty is reflected from the eyes of the old, but it goes through the eyes and into the heart of the young. So, I might say that the beauty I see in a face or a mountain, a river or a forest, the questioning challenge of the design in an old tree or in the markings on a rock, the never-ending loveliness of changing light goes, not just through my eyes to my heart, but through the lens of my camera onto a piece of photographic paper, which I hope will awaken in the viewer's heart the same thrill the original awakened in mine."

— BARRY M. GOLDWATER

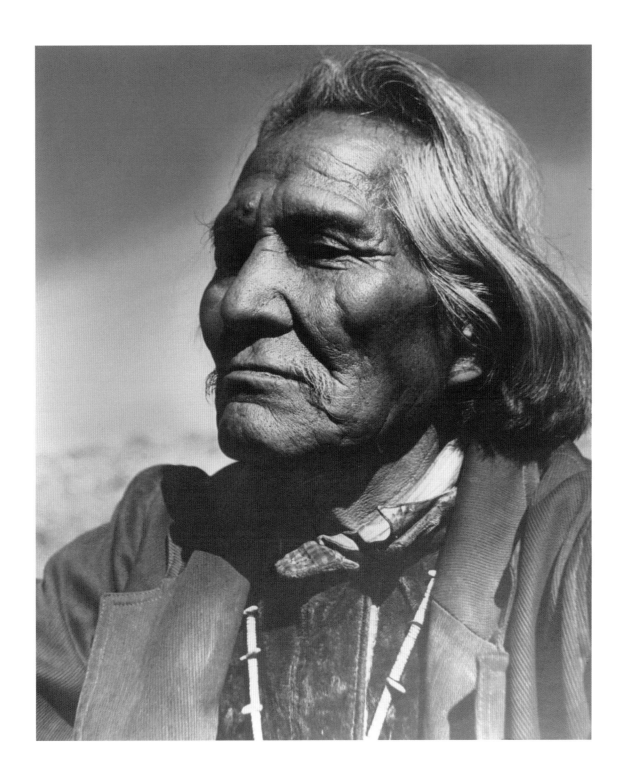

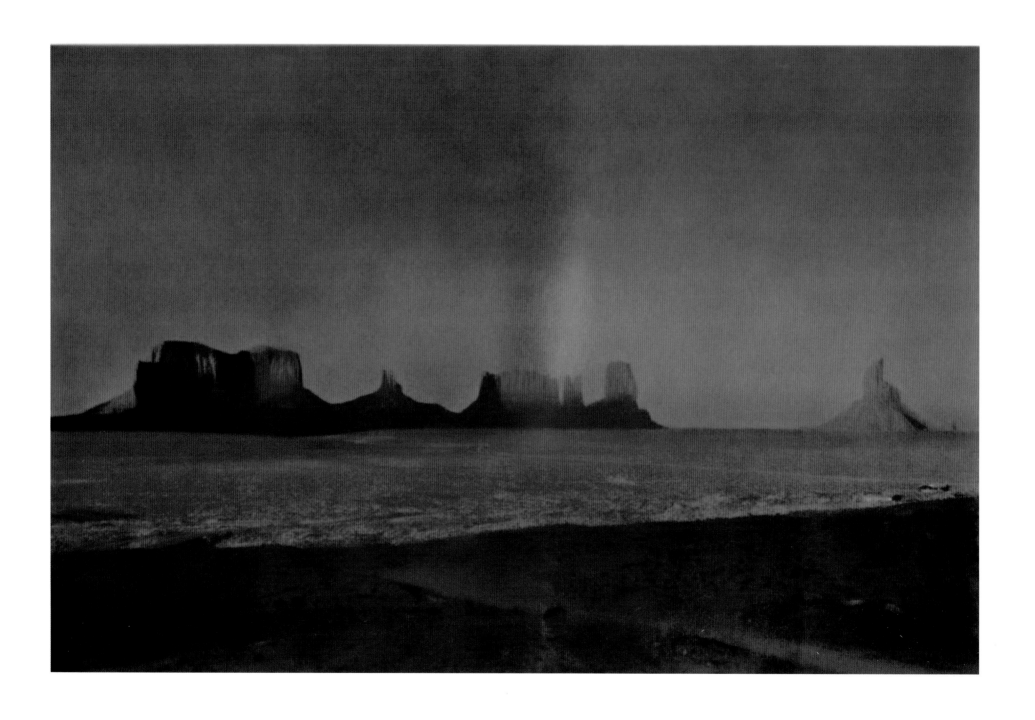

JOSEF MUENCH

DECEMBER 1968
4x5" FILM
MONUMENT VALLEY

Luck certainly plays a major role in photography, but so do planning and access. Josef Muench had to wait for this photograph. He knew where he had to be to capture the rainbow. Creating an image like this takes planning. Sure, some of it is serendipity, but knowledge of the area can help nudge luck.

"When I first saw the desert, I liked it. It was new and different. It immediately took on a meaning to me. I had heard it was barren. It isn't. A little cactus — so delicate and beautiful — can hide from you. You have to go slowly and look carefully."

— JOSEF MUENCH

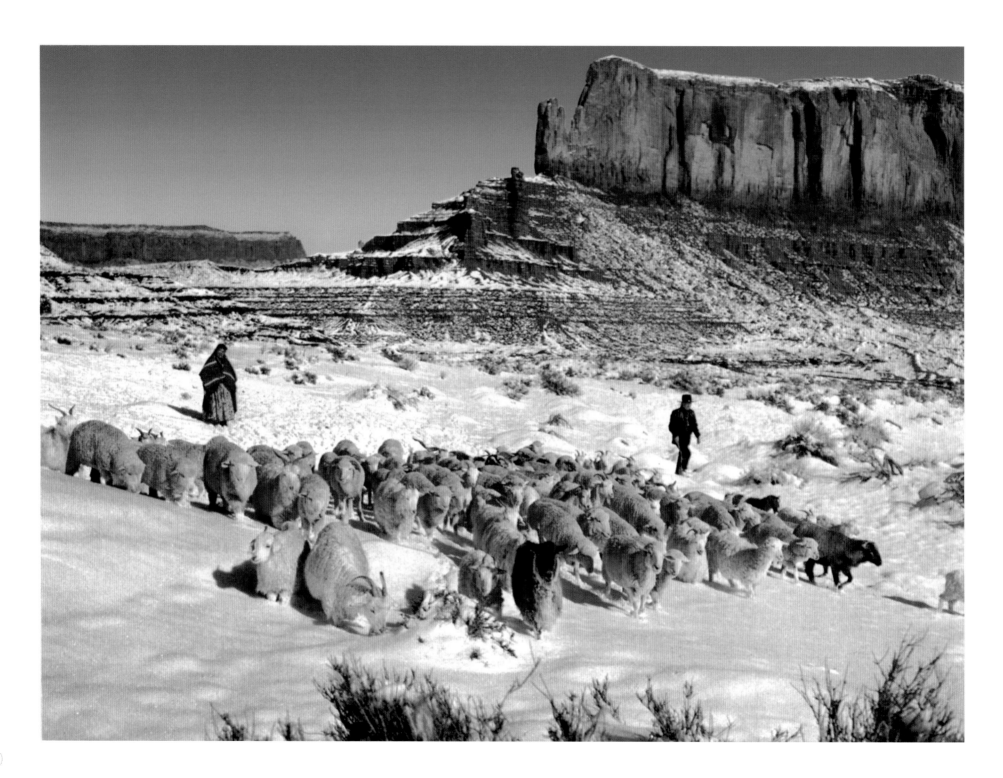

BOB BRADSHAW

DECEMBER 1968
4x5" FILM
MONUMENT VALLEY

This image represents the harsh living conditions in Monument Valley for the Navajos. There's a documentary aspect to the photograph — you can see that life does go on. The image is interesting because of Bob Bradshaw's use of the grass in the foreground as a barrier. He's a bit removed from what's going on, so it's as though he's introducing the scene without influencing it.

"Bob Bradshaw bought his first 35 mm camera in 1936 for $12.50 and learned how to develop film and make prints, even before he graduated from high school. He hopped freight trains and hitchhiked in search of work as a young man, always taking snapshots of the people and countryside he visited. He rode the rails to all 48 contiguous states in search of a dream place to live. He ended up in Sedona, Arizona."

— JOHN BRADSHAW, Bob Bradshaw's son

DAVID MUENCH

SEPTEMBER 1971
4x5" FILM
MONUMENT VALLEY

David Muench differentiated himself from other photographers by working with long telephoto lenses. He took foregrounds and backgrounds and compressed them, which made for some powerful imagery. When he started using long lenses, it changed the look of his work. It also changed how people saw the world through his photographs.

"This image required pre-visualization, which a lot of my images do. I had to hike around one of the mesas to get everything lined up for this shot, all while capturing the very late light."

— DAVID MUENCH

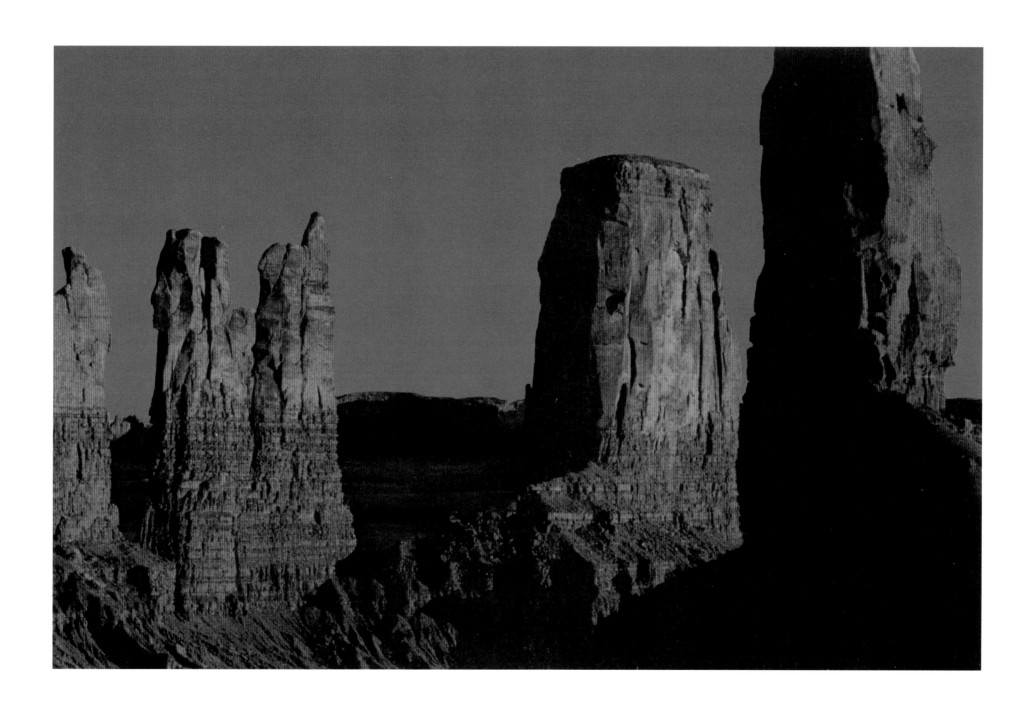

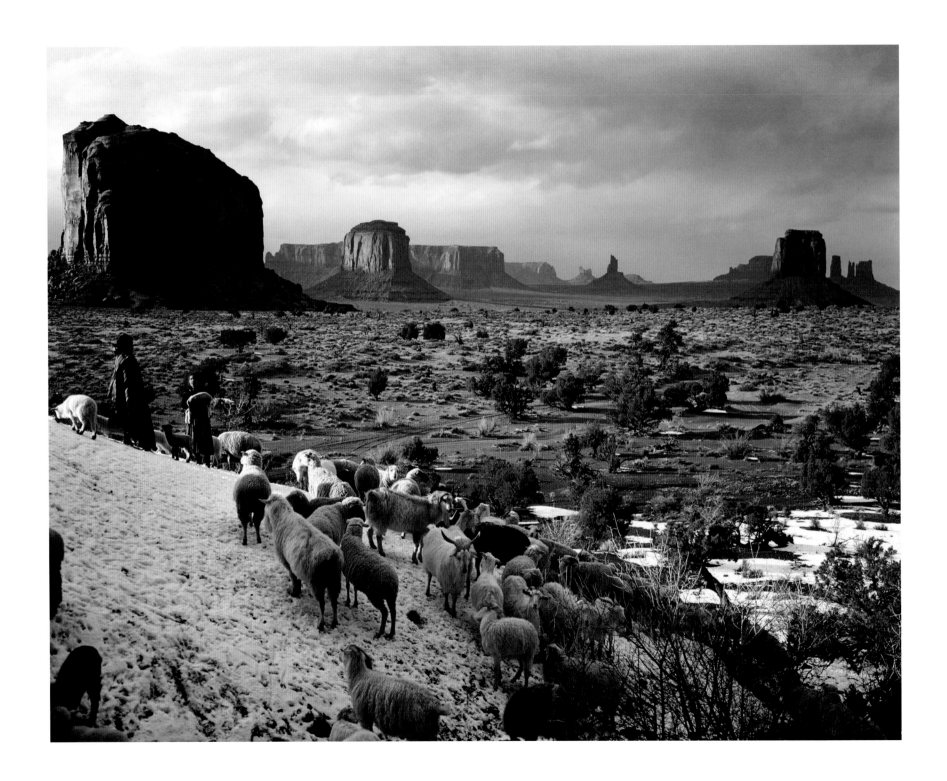

JOSEF MUENCH

JANUARY 1973
4x5" FILM
MONUMENT VALLEY

There's intimacy to this photograph. If you look closely at the frame, some of the sheep are partially cropped out of it. You feel like you're part of the image. Josef Muench's connection to the people he photographed allowed him to be a part of these scenes — not just an observer. He was allowed to travel with his subjects, to be with them. If you don't have access, you can't witness this scene — at least not from this angle.

"I always feel that in Arizona, the scenery comes right out to meet the photographer, as though it considered one of its primary purposes to pose for brilliant, unforgettable pictures. There's so much variety: Incredible rock formations, draped on colored horizons, like skyscrapers of an untenanted metropolis. Giant saguaros, like trademarks of the fascinating Sonoran Desert, punctuate wide sweeps of arid lands. Perhaps your interests tend toward an Indian scene, biblical in its simplicity with long-skirted women at the loom; men, their black hair done in a long knot; and children of the sun watching their flocks."

— JOSEF MUENCH, *Arizona Highways*, October 1952

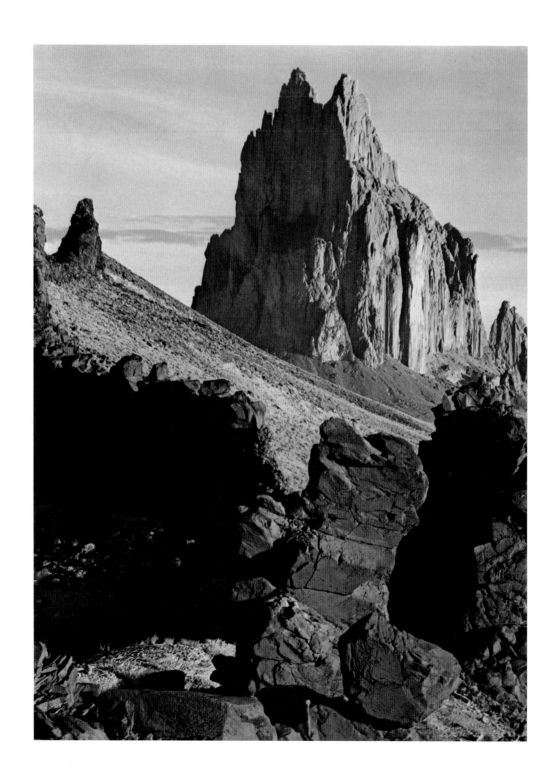

DAVID MUENCH

AUGUST 1973
4x5" FILM
SHIPROCK

Light and texture make this photograph exceptional. There are multiple layers in the image, and David Muench stair-steps you through the photograph. The jagged rocks in the foreground are softened by the gentle textures in the midground. Then, you're back to the harshness of the rocks. Because everything is side-lit, the rock textures are emphasized. It speaks to strength.

"I was moved by the rocks on the dike going towards Shiprock. That's part of the whole volcanic activity that created Shiprock and the surrounding area. The way these angular formations sat there fascinated me."

— DAVID MUENCH

GARY LADD

NOVEMBER 1973
35 MM FILM
KITT PEAK OBSERVATORY

This image pulled Gary Ladd into the profession. The cars and the building are like models that someone created, and the symmetry of the lightning strikes is exceptional. After this photograph ran in the magazine, there were countless requests to run it again.

"One bolt hit so close that I was afraid my camera might have recorded an exposure without the use of its shutter. Needless to say, I couldn't get into the building fast enough. Once inside, I continued to photograph the storm through a large window."

— GARY LADD

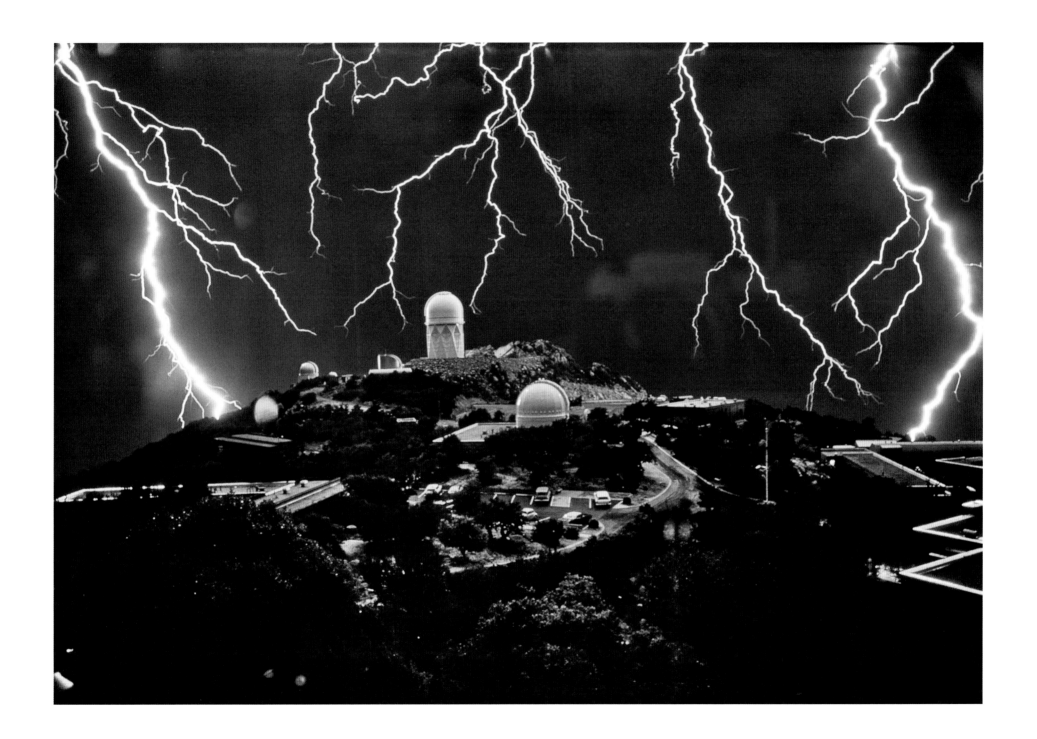

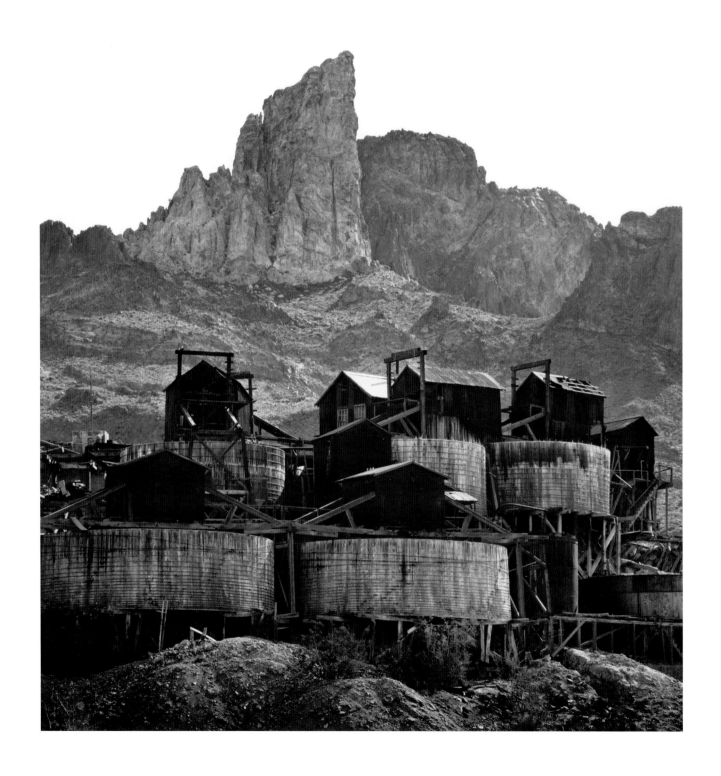

ANSEL ADAMS

OCTOBER 1976
8x10" FILM
OATMAN

There's a strong juxtaposition between the man-made structures and the mountains in this photograph. Everything is vertical, and because the image is black and white, all you see are the wonderful shapes and forms. Compositionally, many people might have shot this horizontally, but Ansel Adams saw the verticality of the shapes in the lower half of the frame. The mountains in the upper half of the frame balance the buildings.

"Art is both the taking and giving of beauty; the turning out to the light, the inner folds of the awareness of the spirit. It is the recreation on another plane of the realities of the world; the tragic and wonderful realities of Earth and men, and of all the interrelations of these."

— ANSEL ADAMS

RAY MANLEY

FEBRUARY 1980
4x5" FILM
DAVE ERICSSON RANCH, WIKIEUP

Ray Manley was a lot of things — he was part documentary photographer and part studio photographer. Here, he used his studio skills to illuminate the faces of the cowboys. There's a strobe light positioned at the base of the campfire, and he balances the last remnants of daylight with the campfire and adds a little bit of strobe to put light on the faces.

"He had a natural talent for composition — for getting the right light."

— **NAURICE KOONCE, former partner at Ray Manley Commercial Photography**

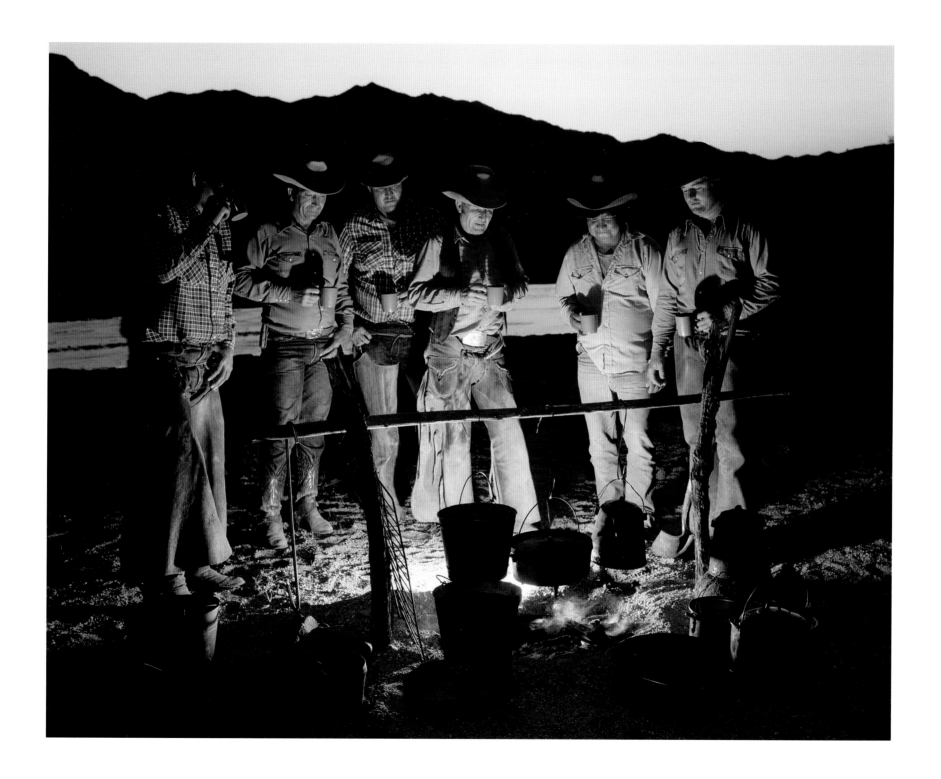

DAVID MUENCH

MAY 1980
4x5" FILM
BABOQUIVARI PEAK

This image came from one of David Muench's sky islands series. The desert is juxtaposed against the peaks in this double exposure. It's a wonderful example of Muench's ability to pre-visualize an image.

"This is a double exposure, so you have sunset and sunrise in the same image."

— DAVID MUENCH

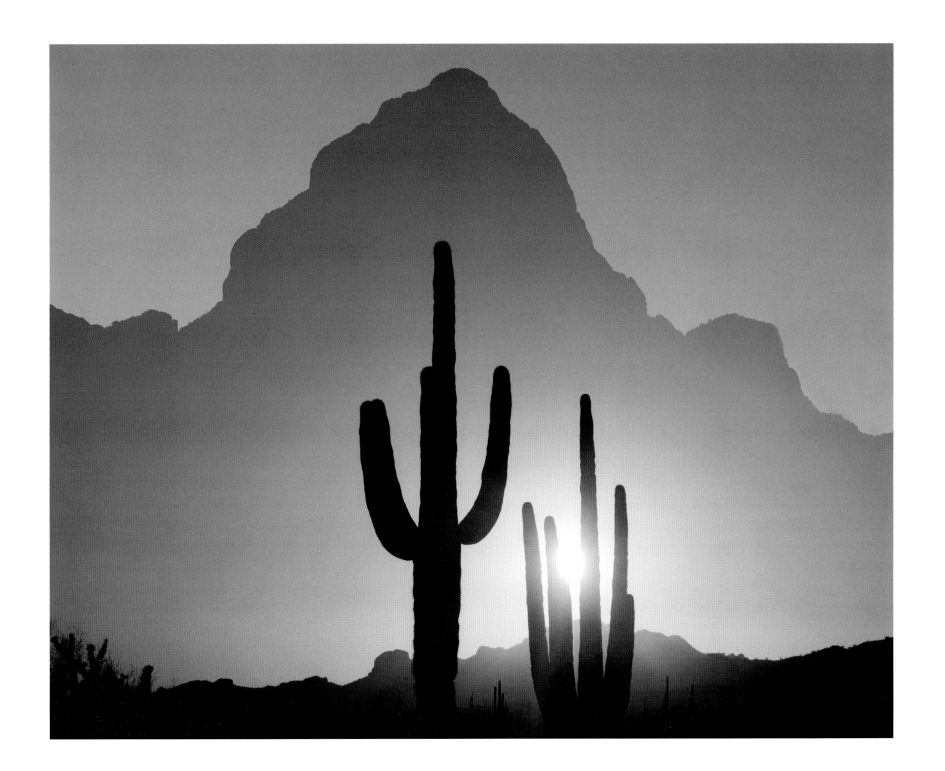

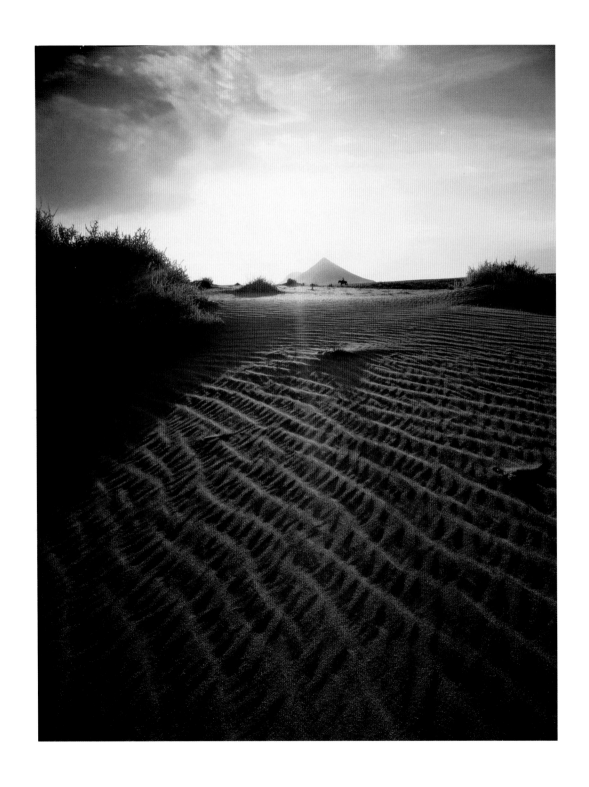

JERRY JACKA

SEPTEMBER 1980
4x5" FILM
HOPI RESERVATION

Sometimes, the most obscure detail can make a photograph extraordinary. This image appeared in an article titled *Hopiland*. Made with a wide-angle lens, the photograph transports you to another place. As your eye follows the texture in the sand, you hit the visual roadblock of the horse and rider. They become an accent mark, and that's what makes the shot.

"I didn't know until after the film was processed that the man on horseback had appeared on one of the four exposures I took. I don't know if he saw me. I don't know where he came from or where he went, so I call this photograph *Ghost Rider.*"

— JERRY JACKA

JERRY JACKA

SEPTEMBER 1980
4x5" FILM
HOPI RESERVATION

It's nearly impossible to photograph on First Mesa today, and although there are a number of historic images, there's never been one like this. The color gives this photograph its ethereal quality, and the glow around Walpi, a sacred Hopi village, is pure magic.

"I contacted the village chief, and he allowed me to take the photograph. I was not allowed to use a tripod. As I was in my vehicle, I rested the camera on the open door and snapped the picture."

— JERRY JACKA

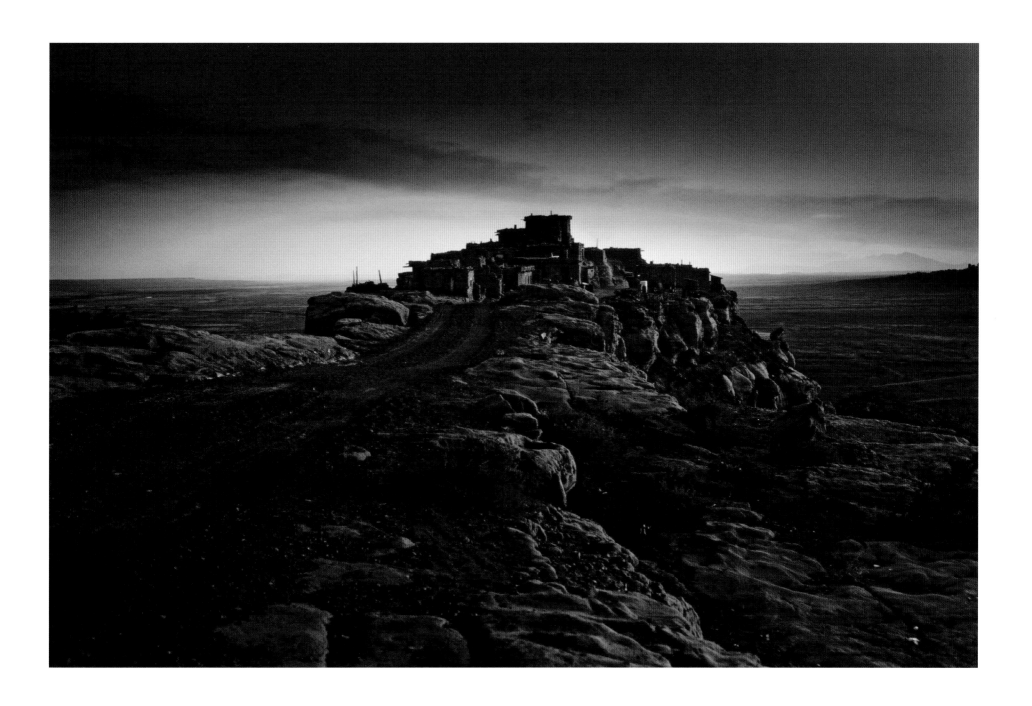

J. PETER MORTIMER

NOVEMBER 1980
35 MM FILM
NOGALES

J. Peter Mortimer and Jeff Kida were working together on a story about Nogales when Mortimer found this old cowboy, who claimed to be 103 years old. Despite his age, he saddled up his horse and rode daily. This portrait, which was taken in the doorway of the old cowboy's home, is really a then-and-now photograph. It's a portrait of contrast between the old man and the young boy.

"The old man was a working cowboy. We stopped by the bunkhouse, and he was teaching the young kid in the photograph how to be a cowboy — how to rope and wrangle. That old man could still break horses."

— J. PETER MORTIMER

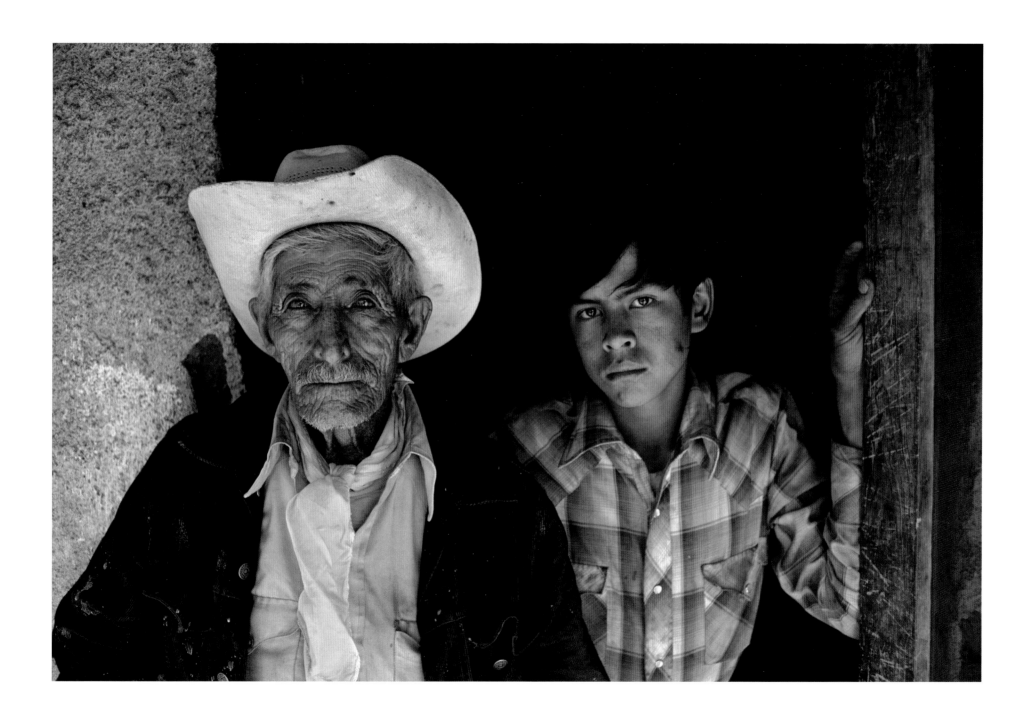

JEFF KIDA

JUNE 1981
35 MM FILM
CO BAR RANCH, NORTH OF FLAGSTAFF

This photograph resembles a movie still — but it's real. Shot at the CO Bar Ranch in Northern Arizona, it depicts authentic action on the open range, where horses are trucked to wherever they're needed.

"*Working Cowboys* was the first big photo essay I shot for *Arizona Highways*. And because I grew up in suburban Northern Virginia, everything I witnessed at the CO Bar Ranch was new and spectacular. I felt like I was on a movie set. This ranch is so expansive, the cowboys truck horses to distant pastures to save both time and energy. To be honest, I was so surprised to see the horses jumping from this truck without using any kind of ramp that I almost missed the shot."

— JEFF KIDA

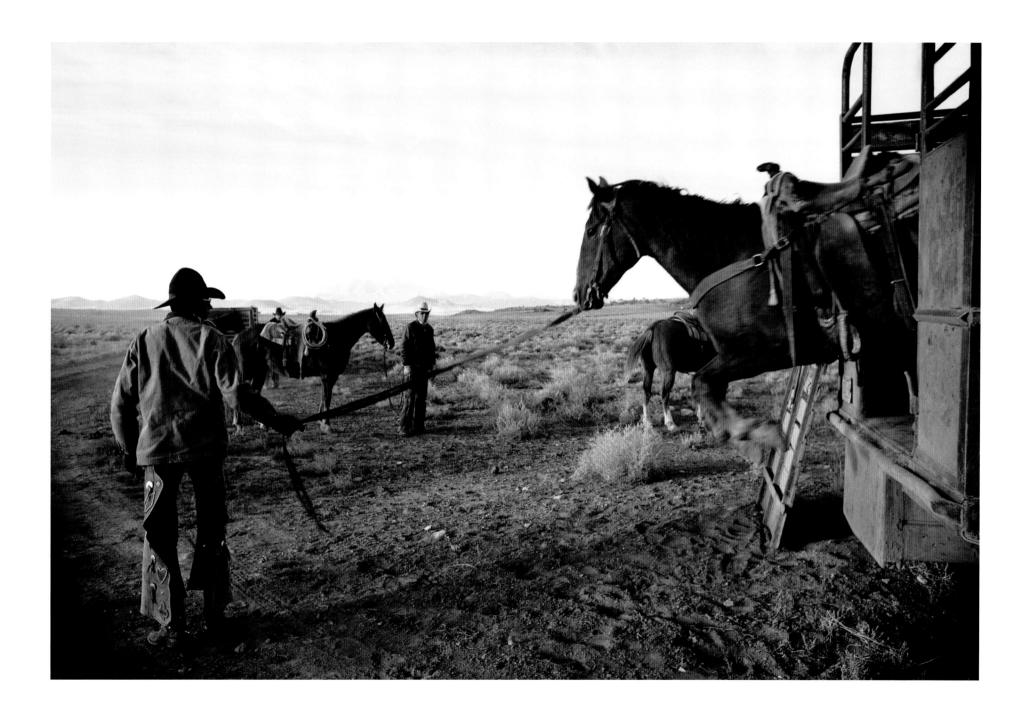

JOSEF MUENCH

SEPTEMBER 1981
4x5" FILM
MONUMENT VALLEY

Long before Hollywood came to call on Monument Valley,
Josef Muench was capturing its beauty. Muench's photo-
graphs of Monument Valley, and the location now known as
John Ford Point, sold Hollywood on the area. Much of the
West that people know about is from the movies — Hollywood
is standing on the shoulders of Josef Muench.

"Nowhere in the world can one find a similar
effect of nature's work."

— JOSEF MUENCH

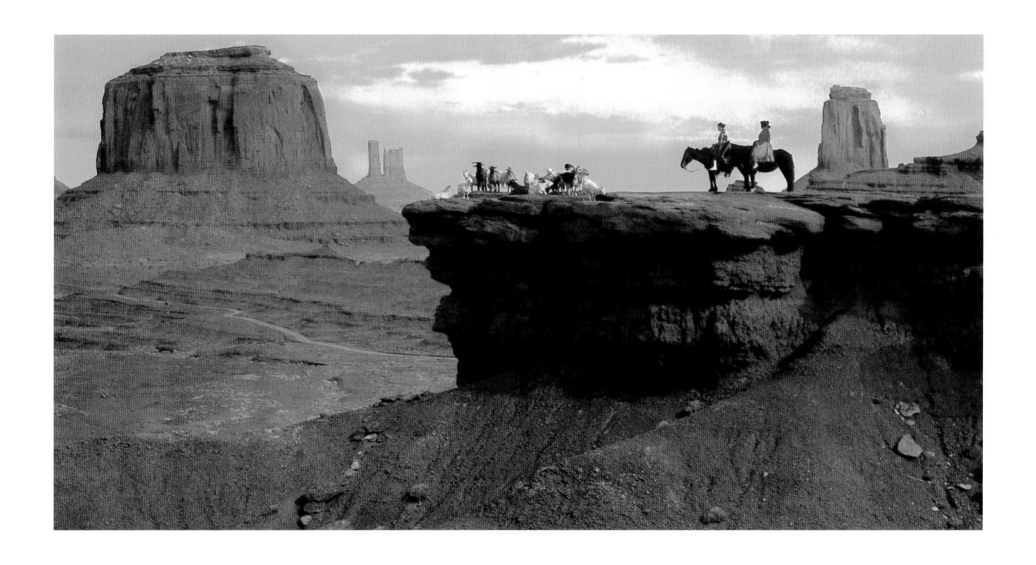

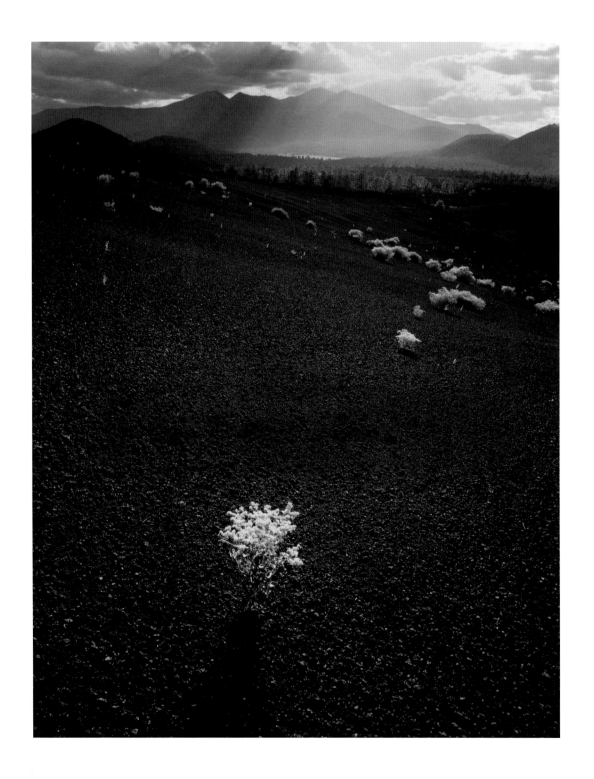

DECEMBER 1981
4x5" FILM
SUNSET CRATER

This photograph pushes compositional boundaries. The San Francisco Peaks are in the upper one-eighth of the frame, and the buckwheat is in the lower third of the image. For David Muench, composition is intuitive. But then there's also the narrative itself. The single buckwheat plant against the black cinders speaks to survival.

"When you're working with backlight, you have to figure out how to make the image interesting. How do you carry the eye from one object to the next?"

— DAVID MUENCH

JAY DUSARD

AUGUST 1982
8x10" FILM
SKULL VALLEY

Portraits, though they focus on an individual or multiple people, don't always tell the story. This one does. Jay Dusard is a fine-portrait photographer, and he knew these subjects very well. What's interesting is Dusard's use of light, the barn wood and the implements, which help tell the story.

"It's very reminiscent of an abstract photograph by Aaron Siskind, one of the photographers who has influenced me and my work."

— JAY DUSARD

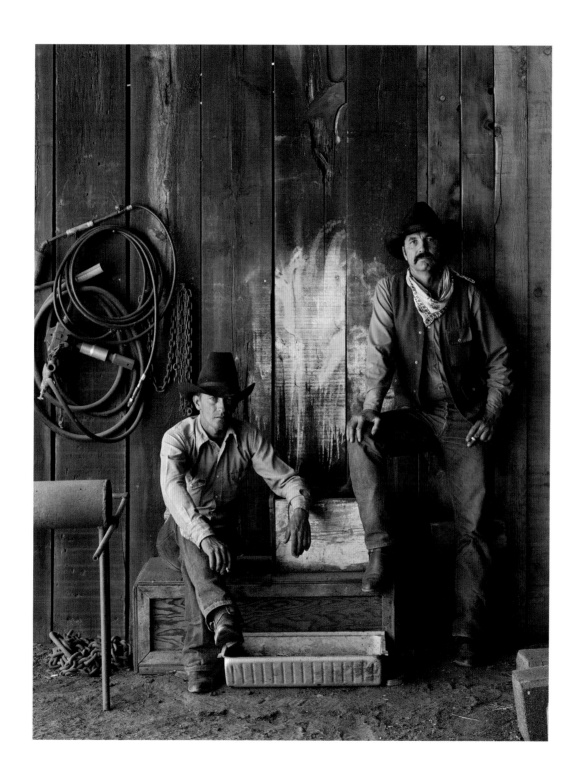

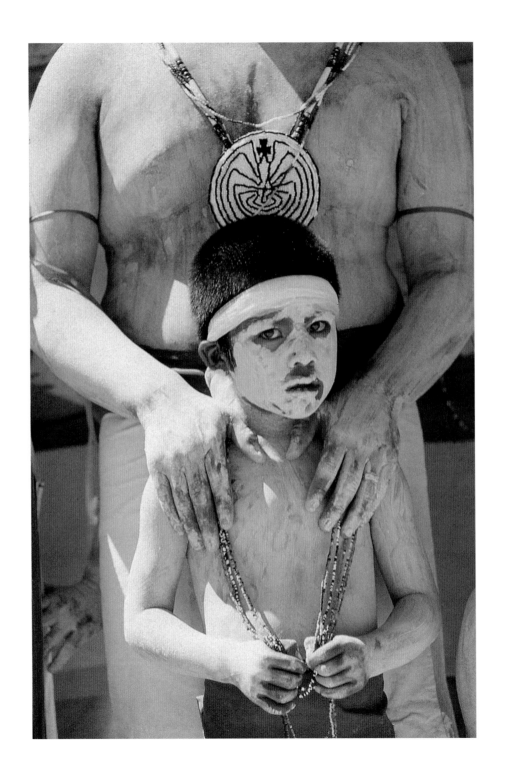

P.K. WEISS

APRIL 1983
35 MM FILM
MISSION SAN XAVIER DEL BAC

This photograph tells a coming-of-age story. The adult is cropped right at the chest. All you see of the man are his medallion and his massive hands on the boy's shoulders. The boy is tentative — he clings to his little beads, unsure of what's about to happen. This image speaks to vulnerability, to the great uncertainty about what's next.

"Aside from the eye contact, the arms create these repetitive shapes, which is mimicked by the Tohono O'odham Man-in-the-Maze symbol. It gives the image this 'search for the meaning of life' symbolism."

— P.K. WEISS

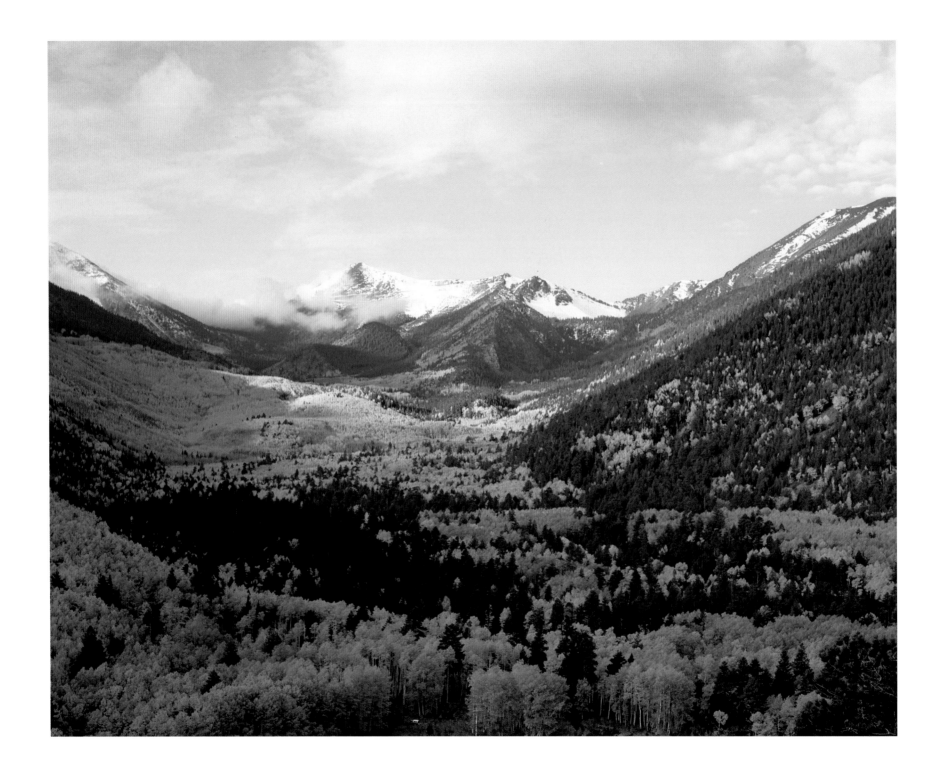

LES MANEVITZ

OCTOBER 1986
4x5" FILM
LOCKETT MEADOW

In addition to its fabulous color palette, the perspective of this photograph makes it stand out. There are countless photographs of Lockett Meadow, but very few were made from this perspective, which enables us to see the enormity of the beautiful valley.

"I was new in the business when I put my 4x5 Calumet camera in my pack and climbed up the side of the opposite mountain. I found a clearing and took my shot before the clouds covered the peaks."

— LES MANEVITZ

JACK DYKINGA

MAY 1987
4x5" FILM
MONUMENT VALLEY

Jack Dykinga saw this branch spinning in the wind. Circles are compositionally amazing forms — they draw you in — and the branch is moving like a little clock. The photograph speaks to the passage of time in a timeless place.

"As often happens, some of the best images are created from disappointment. Your preconceived notion doesn't carry the day. Surprise and serendipity are what make it work."

— JACK DYKINGA

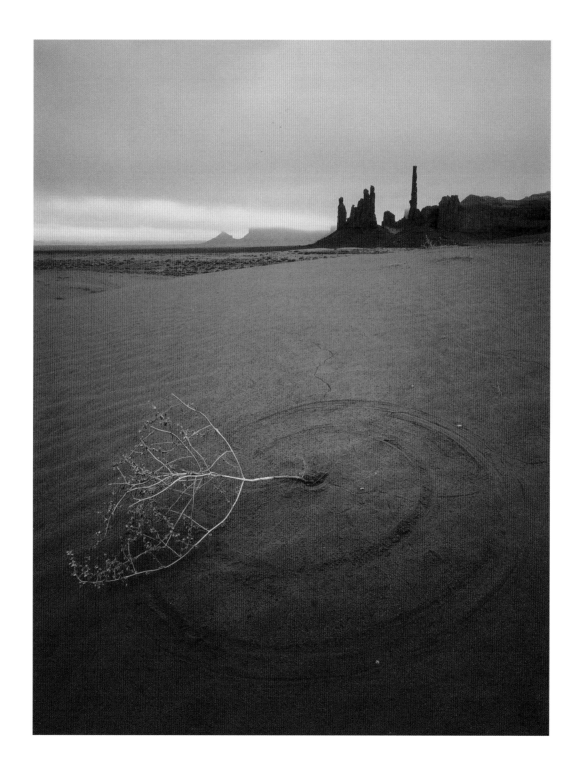

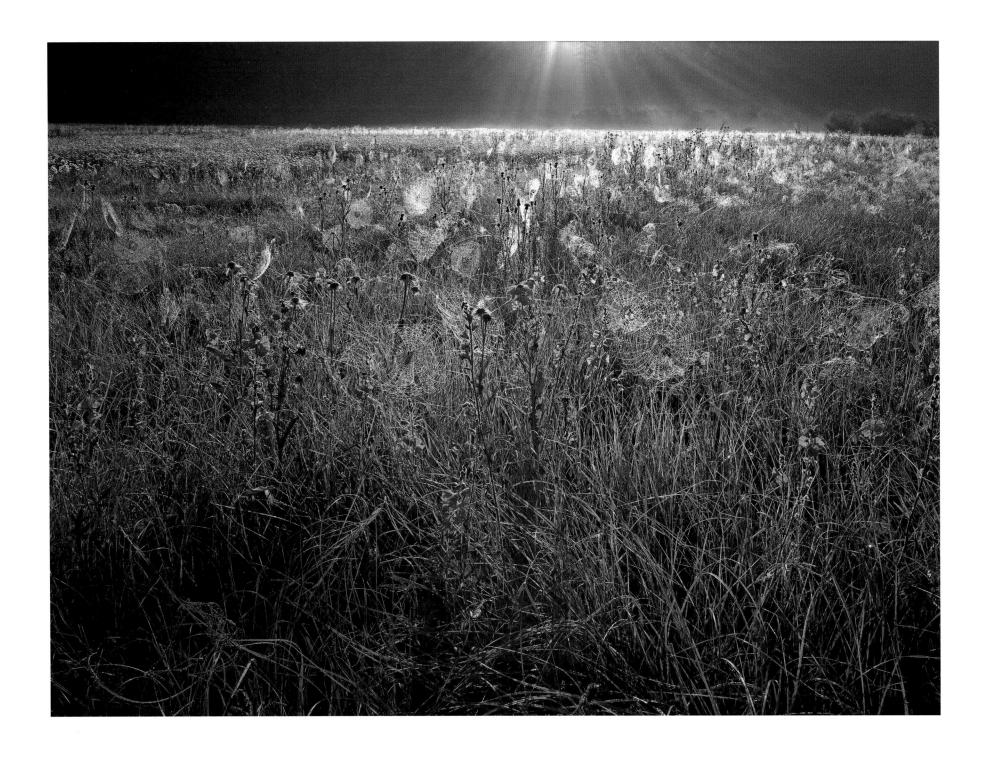

BOB AND SUE CLEMENZ

DECEMBER 1987
5x7" FILM
WHITE MOUNTAINS

Bob and Sue Clemenz had just returned from a road trip when fellow photographer Larry Ulrich called to tell them about this White Mountains meadow. At Ulrich's insistence, the Clemenzes eventually agreed to meet him, and they captured this image. They chose to use backlight, which made the spider webs glow and pop, and the color of the flowers is magical.

"Even when we walked across the field, I thought: 'We've seen fields of wildflowers before. What's so special about this scene?' But then the sun came up, and we saw all of these wonderful spider webs."

— SUE CLEMENZ

FRANK ZULLO

FEBRUARY 1988
35 MM FILM, FROM TWO TRANSPARENCIES
SUPERSTITION MOUNTAINS

Before there was Photoshop, there was Frank Zullo. Zullo made two separate photos to produce this final image. The first was a 10-minute exposure of Halley's comet, and Zullo used an equatorial mount. The apparatus allowed him to track the rotation of the Earth, which kept the stars as pinpoints while revealing the long tail of the comet. He made the second photo — of the Superstition Mountains at dusk — on Kodalith film. It's a very high-contrast black-and-white film that rendered an inky black silhouette. Zullo then layered the images and photographed them on a copy stand. This photo required both artistic vision and the technical expertise to make it happen.

"I captured what I wanted most: an image of the long-awaited visitor from space. It appears both earthly and otherworldly at the same time. The two large, monolithic rocks that appear to be leaning against one another reminded me of some forgotten Megalithic site. It was the perfect scene for viewing this celestial event."

— FRANK ZULLO

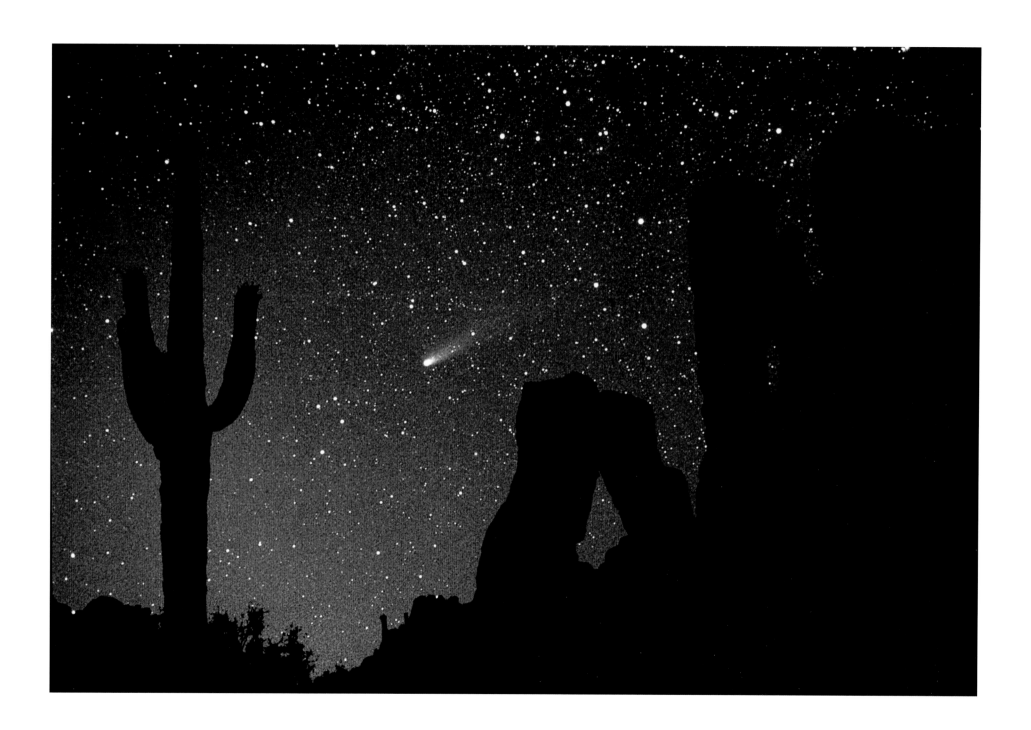

KEN AKERS

FEBRUARY 1989
35 MM FILM
TUCSON

This image was made on film with a 600 mm lens. These were the days before auto-focus, and Ken Akers was as good as anyone when it came to this kind of work. He had a remarkable ability to manually focus his lens and stay with the action. Akers could capture these subtle moments, follow focus and shoot frame after frame.

"From the time Ken shot his first rodeo, he was hooked. He loved documenting the intensity of all sports, but for him, rodeo was king. For any given event, Ken would search out prime positions, knowing ahead of time which lens he would use. For steer-wrestling, it was usually a 600 mm, which he focused manually with unbelievable precision. He truly lived for the moment."

— JEFF KIDA, photo editor, *Arizona Highways*

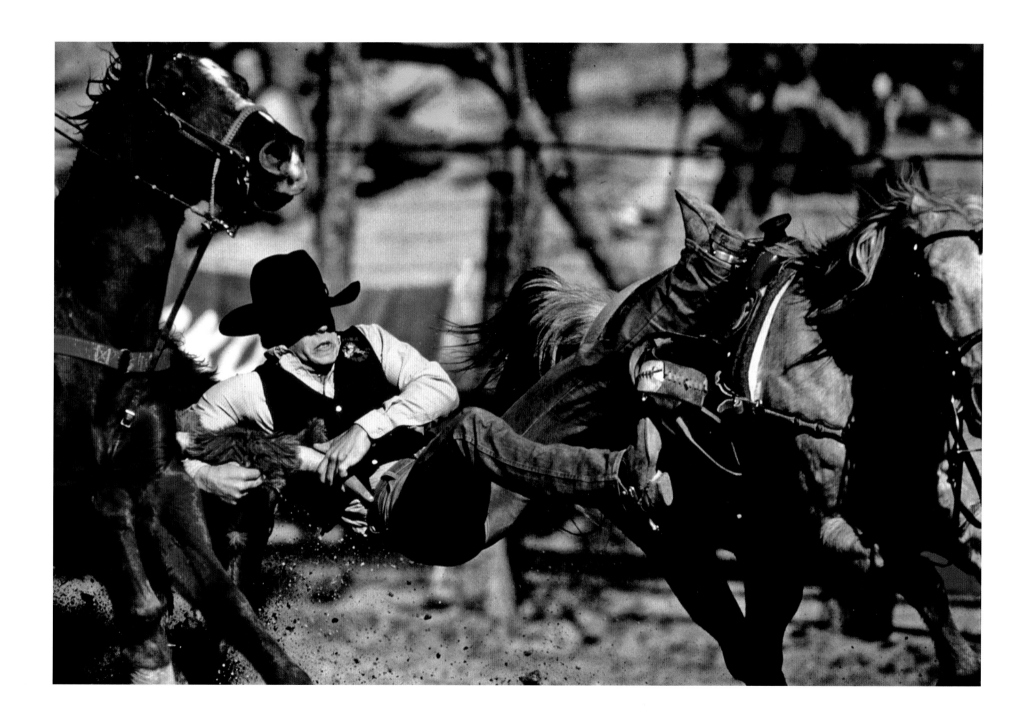

JACK DYKINGA

DECEMBER 1991
4x5" FILM
SAGUARO NATIONAL PARK, TUCSON

This photograph, like Jay Dusard's cowboy portrait (page 59), tells a story. Jack Dykinga made this image with a wide-angle lens — emphasizing the foreground — while framing the cactuses in the background. By taking your eye from the foreground to the background, he's telling you that this is a part of that — it's the story of the saguaro.

"For two weeks, I searched out the perfect cactus and found three or four that might work. I chose this one because the other cactuses were perfectly centered in the background."

— JACK DYKINGA

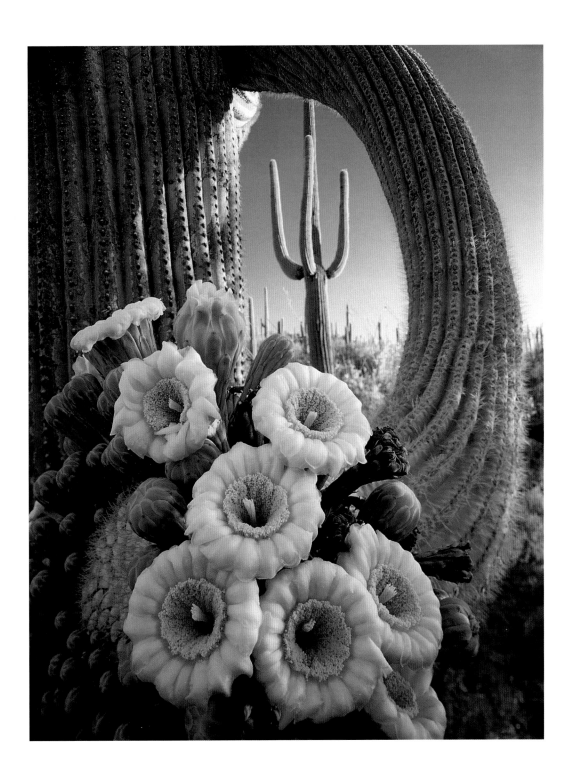

JACK DYKINGA

JUNE 1993
4x5" FILM
BAJA CALIFORNIA

To some degree, this photograph is a bit disarming — the great, sharp thorns and arms look like tentacles — but there's also a bit of whimsy. Jack Dykinga is an expert when it comes to seeing form, and yet, despite the abstractions, your mind has enough information to put this photograph together, to complete it.

"I rarely capture the photograph the way I want it the first time, so I like to revisit things. When I saw there was a thumbnail moon, I went back to my favorite Boojum tree to photograph it. It really is a magical plant — almost surreal."

— JACK DYKINGA

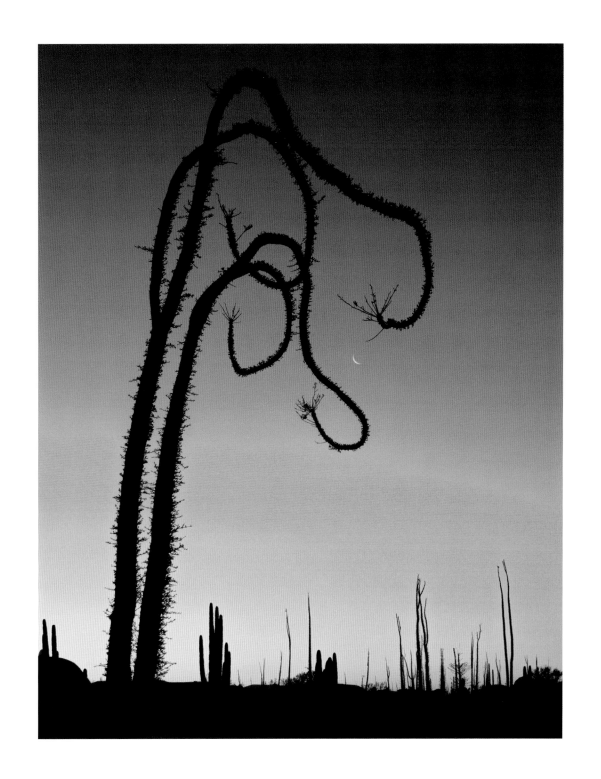

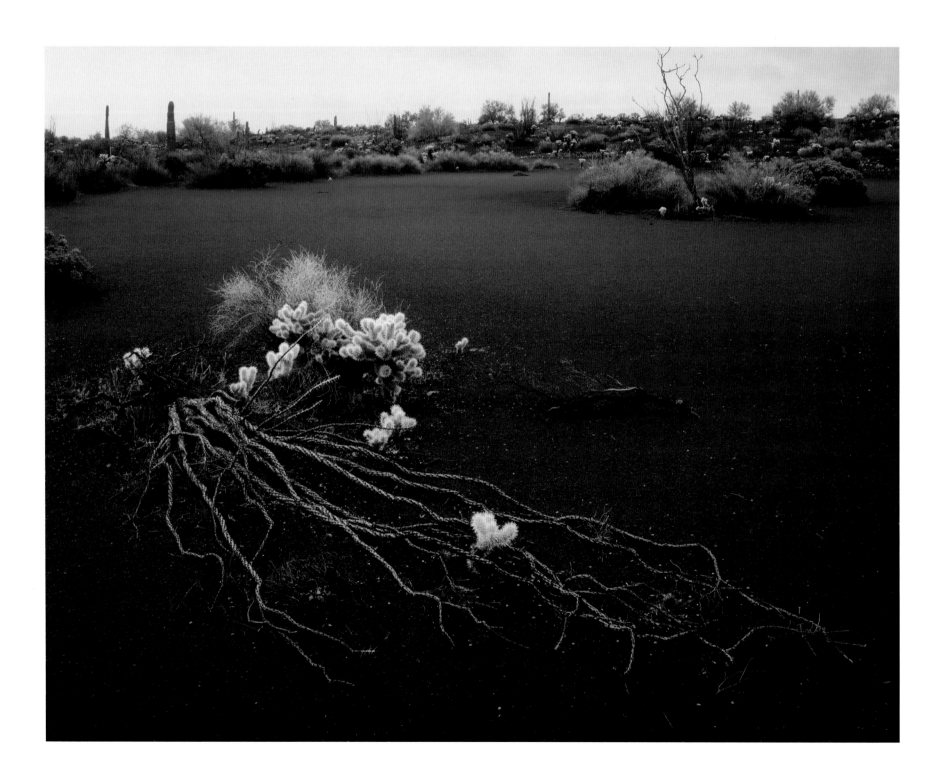

Jack Dykinga's images almost always have a storytelling quality to them, because narrative is very important to him. The downed ocotillo in this photograph takes your eye from right to left and up into the frame. The scene reveals an example of survival in a harsh environment. But it also speaks to the fragility of life — nothing lasts forever.

"This is black volcanic ash from the Sierra Pinacate, a fairly recent eruption site, and what you're seeing is a wind-blown flat of volcanic ash with these islands of vegetation."

— JACK DYKINGA

TOM WIEWANDT

MARCH 1994
4x5" FILM
TUCSON MOUNTAINS

This photograph personifies Mother Nature — as both forceful and life-giving. The image combines rain and hail driving down diagonally, as well as the sunlight breaking through from behind. What results is a wonderful study in textures. The image also says something about the photographer's ability to persevere in lousy conditions.

"My camera, tripod and I were huddled under the eaves of my house. On this summer afternoon, hail and rain fell together, creating an even more unusual tapestry of light, something I've only seen once in 34 years."

— TOM WIEWANDT

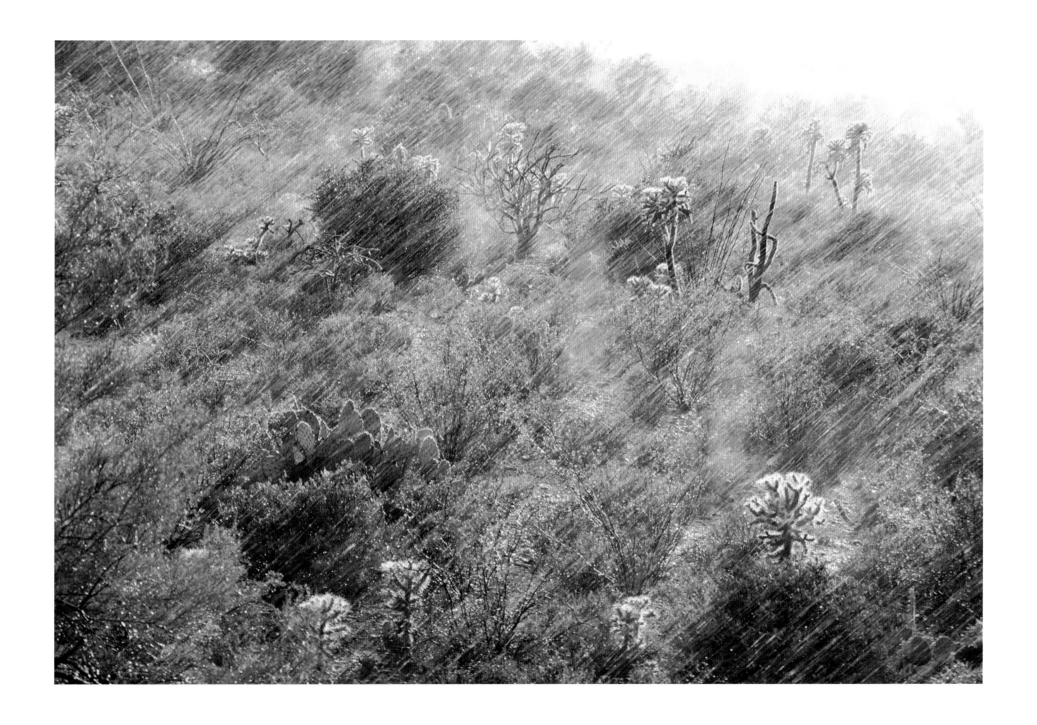

Perspective reigns in this image. It wasn't made from eye level, so you can see the immensity of the herd. There's a graphic quality about the photograph and the composition — nothing is static. Your eye moves naturally through the frame.

"I want to share the beauty of Arizona with as many people as possible. And I feel I can best do this by photographing the notable places in a straightforward manner. Sure, I'll try for an interesting vantage point and wait for the most dramatic lighting, but I won't hide the forest behind a blade of grass. I am using the camera to reveal the beauty of identifiable landmarks and trying to give an honest rendition of the subjects."

— RAY MANLEY, *Arizona Highways*, September 1979

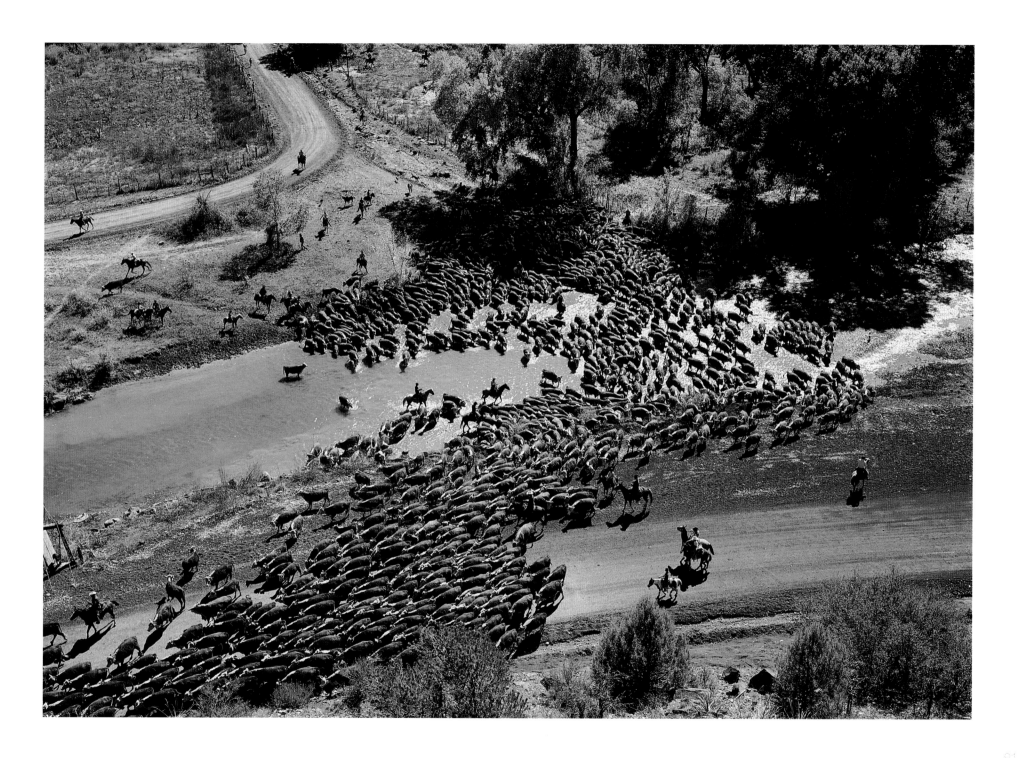

DAVID LAZAROFF

AUGUST 1995
4x5" FILM
SUNSET CRATER

Timing, patience and planning were the key elements in making this photograph — not only when it came to time of day, but also in terms of the phases of the moon. This required vision — you can't go out and make something like this on a whim. Sure, you might see it and get lucky, but people like David Lazaroff do this because they plan it. He did his research, and it's the crescent moon that makes the shot.

"I drove a short distance in the dark, then set off on foot across the barren cinder fields near the volcano. The environment is almost lunar by daylight; by starlight, it was eerie and disorienting."

— DAVID LAZAROFF

RANDY PRENTICE

MARCH 1997
4x5" FILM
SONOITA

The repeating forms and textures of the agaves in the foreground of this photograph act as an anchor for the flower stalks that frame the sunlit mountains in the distance. You can almost feel the peace and serenity of the setting.

"I noticed the leaf pattern of a particular agave and attempted to photograph it, cropped tightly with only leaves in the frame. That idea morphed into photographing the agave-lined horizon."

— RANDY PRENTICE

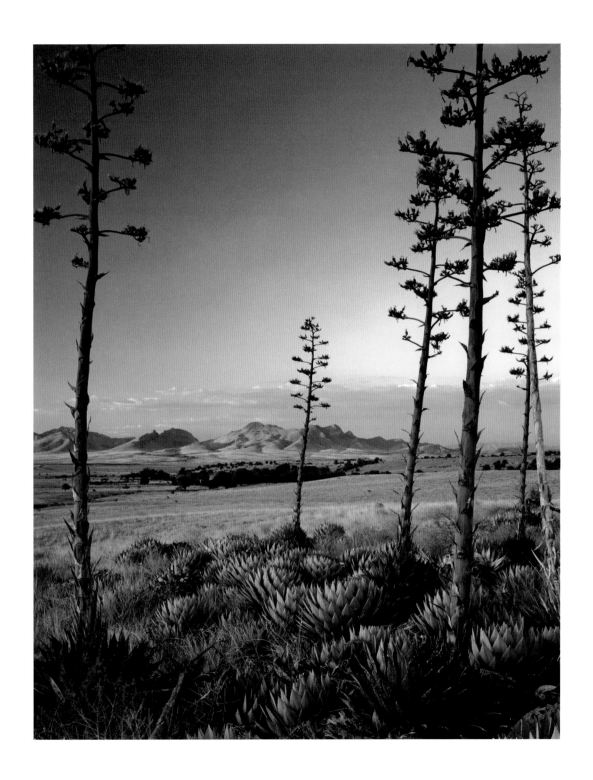

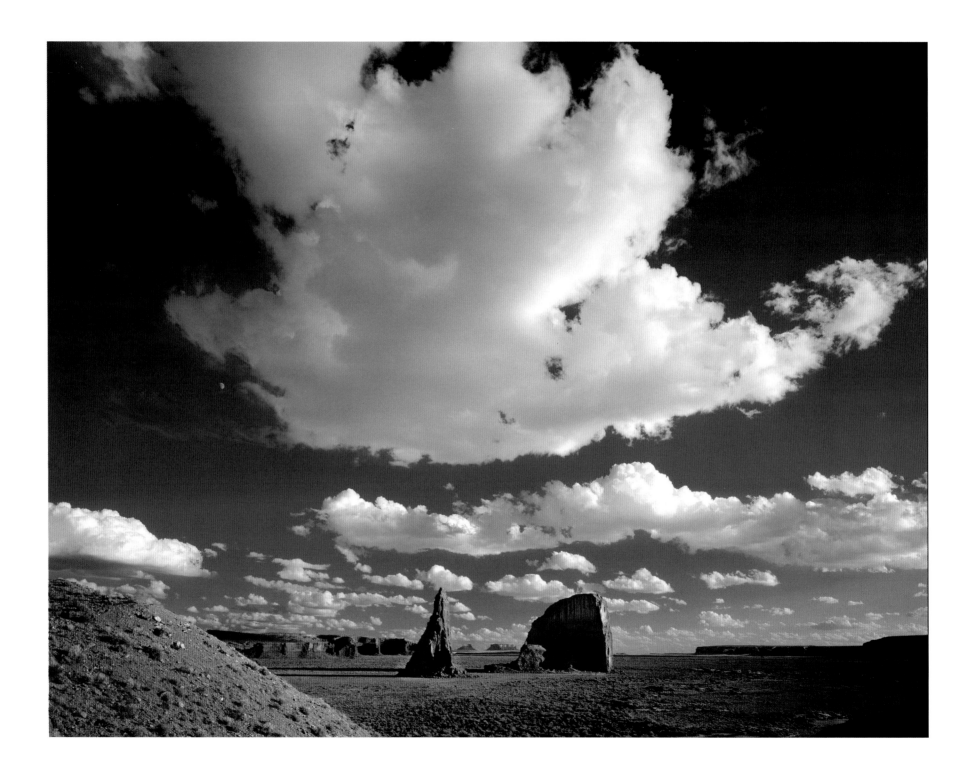

DAVID MUENCH

OCTOBER 1997
4x5" FILM
LUKACHUKAI MOUNTAINS

This is, in many ways, a skyscape — the clouds are the dominant forms here, and the sky speaks to the enormity of the space. It's a contrast of sky and land, a contrast of colors — the very deep, rich blue sky against the reds of the Colorado Plateau. The soft clouds are juxtaposed against the jagged monuments of the Lukachukai Mountains.

"It's Navajoland. It's wild, and there's a sense of space — it's all about the big open sky."

— DAVID MUENCH

RANDY PRENTICE

AUGUST 1998
4x5" FILM
HANNAGAN MEADOW

There are many photos from Hannagan Meadow, but this one stands out because of the weather conditions, attention to detail and composition. Randy Prentice made this photograph in summer, during the monsoon season — everything is green. There are wonderful leading lines with the fence, which is anchored by the flowers in the foreground. There's also a heaviness to the air. This was taken just as the sun crests the horizon, creating an otherworldly feel.

"Capturing this photograph required waking up before dawn and driving several miles to scout camera angles. Certainly, a bit of luck was involved, but the sky and clouds were just right, and that doesn't happen every day."

— RANDY PRENTICE

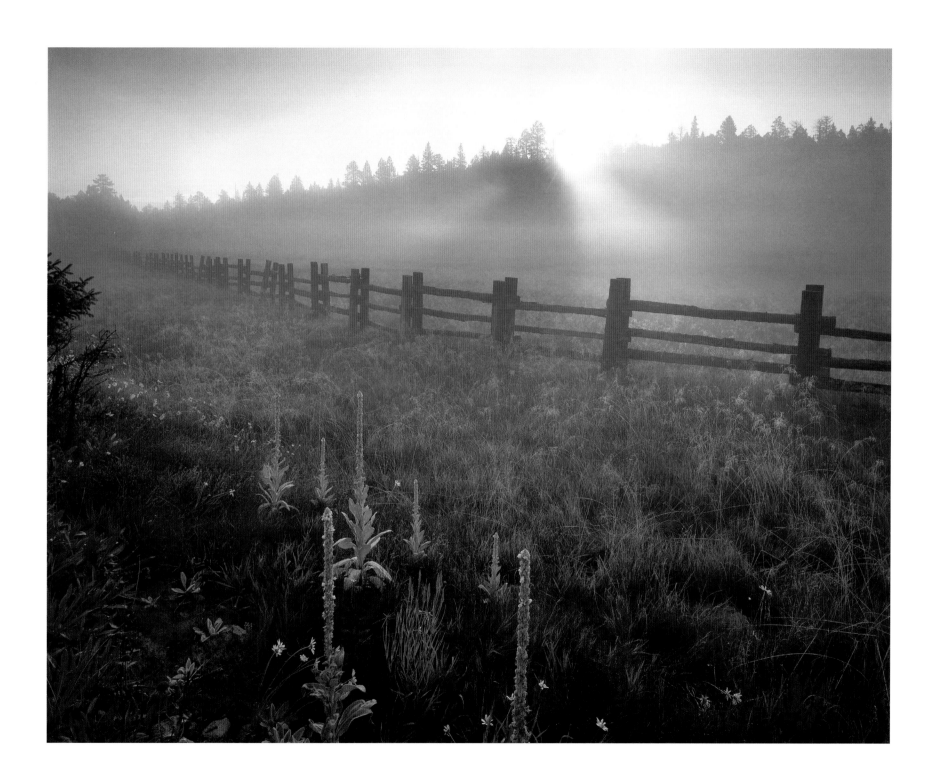

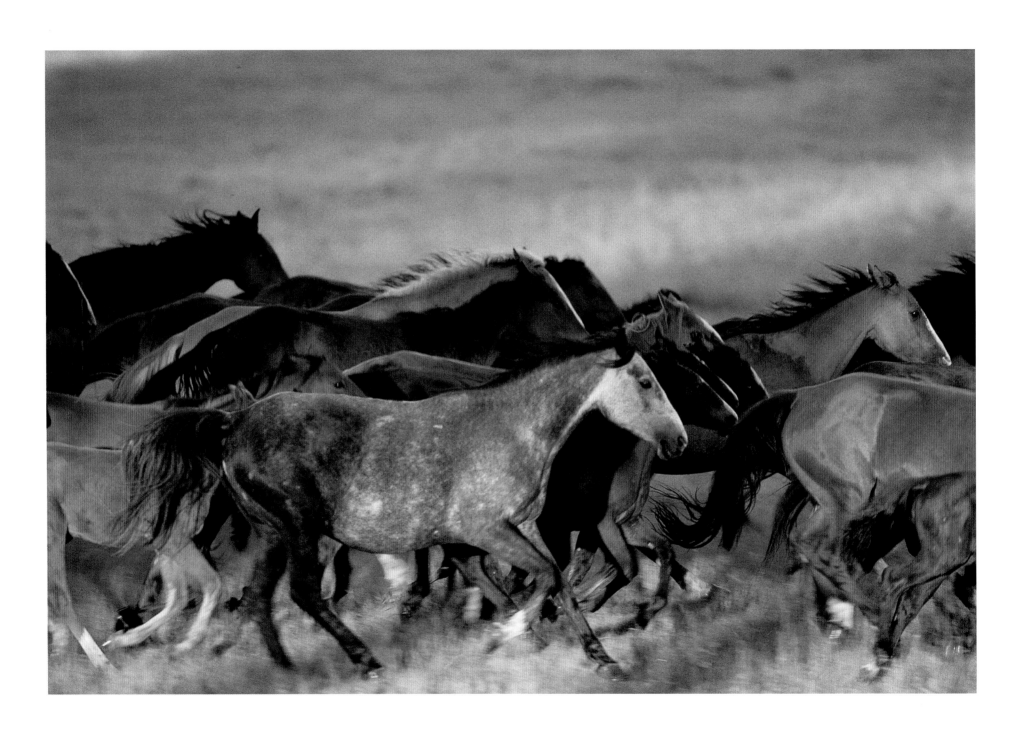

KEN AKERS

NOVEMBER 1998
35 MM FILM
WHITE MOUNTAINS

Movement equates to wonder in this photograph. This was shot late in the day using Kodachrome 200, which was made for only a short period of time. It's a little grainier and has a stippled look to it. Ken Akers used a slightly slower shutter speed and panned to capture the motion of the horses. He fell in love with the cowboy life, and this was one of the images that came out of his cowboy series.

"I remember Ken making preparations to shoot this wild-horse roundup story for *Arizona Highways*. Knowing he'd be working on horseback much of the time, he was absolutely meticulous about film and equipment choices. He had custom bags made for his cameras and lenses that draped over the saddle horn. This made them accessible and kept the constant jarring from the horse's gait to a minimum. He also packed in a lot of Kodachrome 200 film — he knew he'd be working in low-light situations. He also knew this film would render plenty of shadow detail, given the dark coats of many of the horses. He left almost nothing to chance."

— **JEFF KIDA, photo editor, *Arizona Highways***

LON McADAM

DECEMBER 1998
35 MM FILM
FOUR PEAKS

The framing of this photograph makes it one of the greatest. The Four Peaks are a backdrop to the saguaros, and the clouds are wonderful. The inky black tones of the desert floor contrast with the incredible blues and whites of the sky.

"I was looking for saguaros or rock formations to put in the foreground when I came across these saguaros. I set up, and as the clouds came and went, I waited until the foreground was completely in shadow and took my exposures."

— LON McADAM

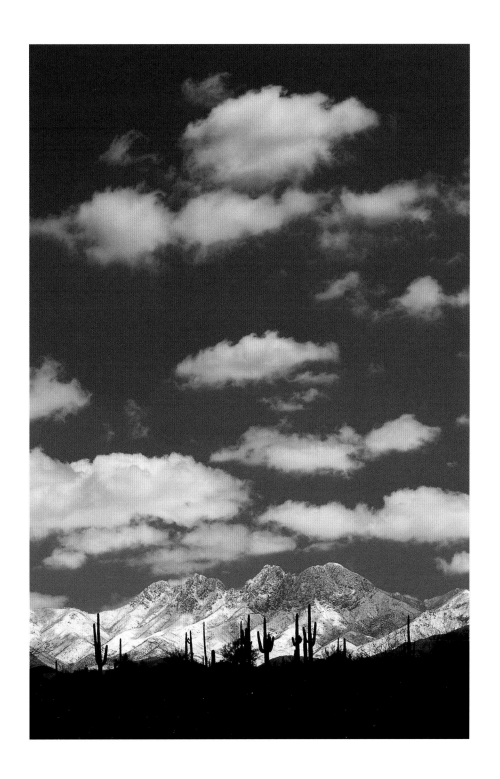

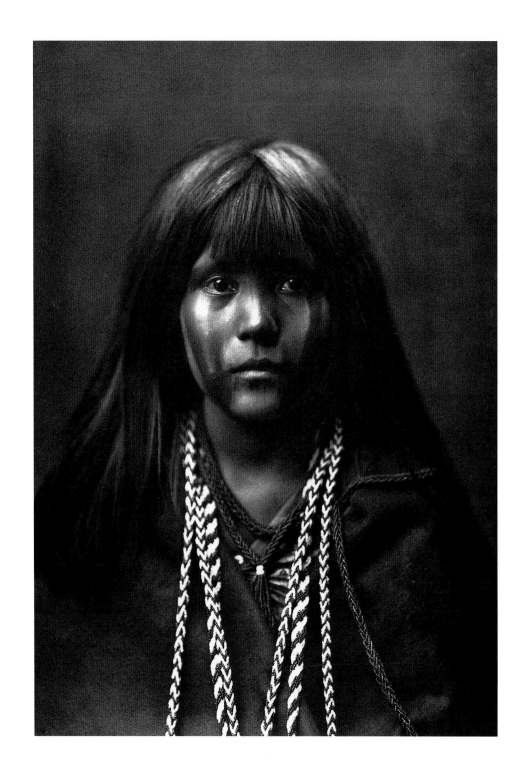

The documentary nature of this photograph made it stand out from similar portraits. Edward Sheriff Curtis documented Indian tribes all over the country, beginning in the early 1900s — he felt the need to record Native American cultures before they disappeared. His work is pure magic. He not only chronicled our history, but also our humanity.

"When I look into the eyes of the women photographed by Edward Curtis, there is an exchange, there is intensity of regard. Curtis mastered the art of making his subject so dimensional, so present, so complete, that it is, to me, as though I am looking at the women through a window, as though they are really there in the print and in the paper, looking back at me."

— LOUISE ERDRICH, American author

EDWARD S. CURTIS

NOVEMBER 1999
GLASS PLATES
WHITE MOUNTAINS

Made in 1906, this image captured a moment in human history. These are White Mountain Apaches, and they're performing what's called the Dance of the Gods. Edward S. Curtis used huge glass plates, which predated film, to make this image. It not only speaks to the documentary nature of his work, but also to the technology available to photographers at the time.

"The passing of every old man or woman means the passing of some tradition, some knowledge of sacred rites possessed by no other. Consequently, the information that is to be gathered, for the benefit of future generations, respecting the mode of life of one of the great races of mankind, must be collected at once or the opportunity will be lost for all time."

— EDWARD S. CURTIS

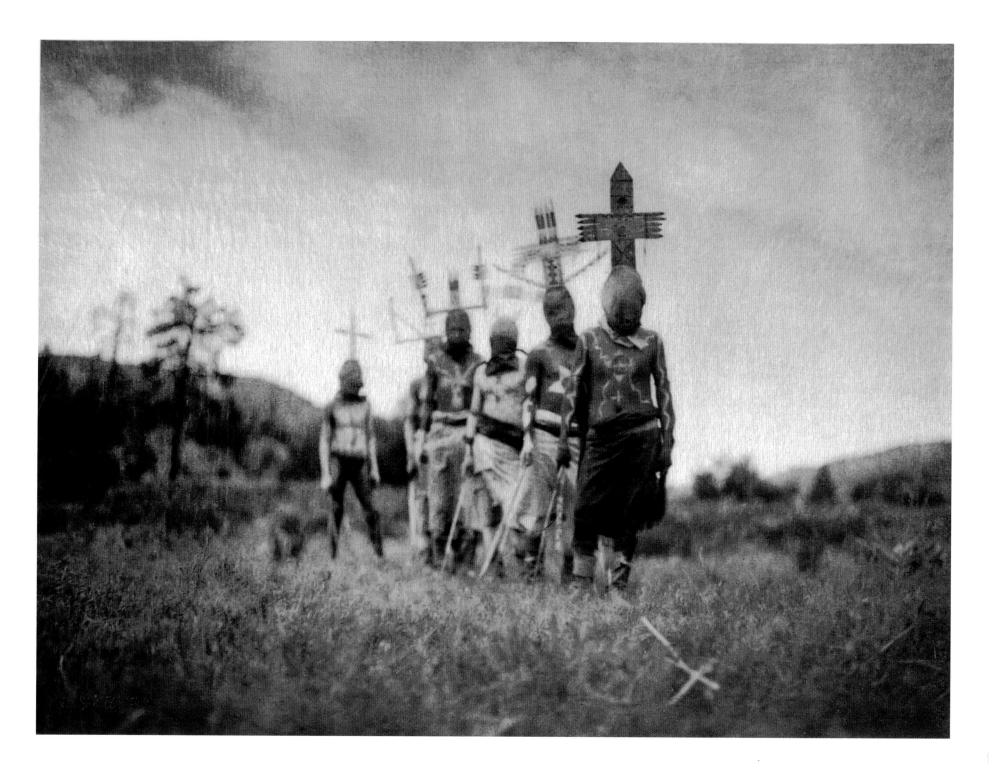

RANDY PRENTICE

SEPTEMBER 2000
4x5" FILM
WHITE MOUNTAINS

This photograph beautifully captures what, in photography, is known as the "magic hour," although that so-called hour is really just a matter of minutes. You can almost feel the moisture in the air, and maybe there's a quiet breeze. There's a painterly quality to this image, there's dimension to it. Truly, this is magic light, and it didn't last for more than a few minutes, if that.

"Shooting toward the sun created contrast issues. I solved this problem by burning in the bottom half of the scene. So, by slightly fanning my dark slide over the top half of the lens for a few seconds, more light exposed the lower foreground where the mullein and daisies are."

— **RANDY PRENTICE**

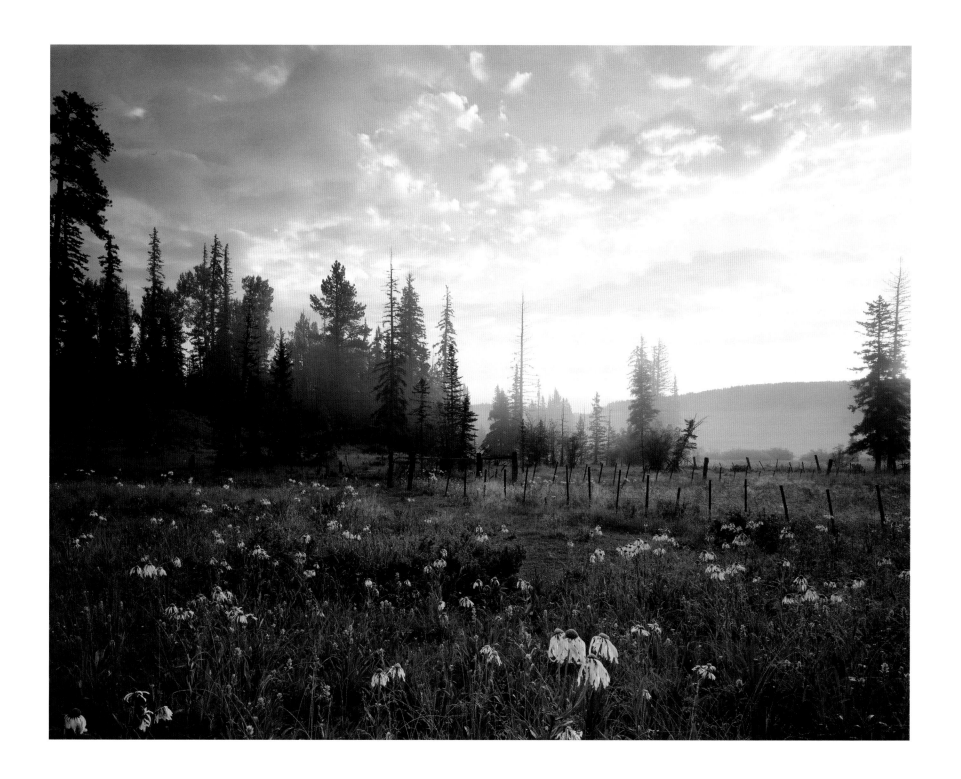

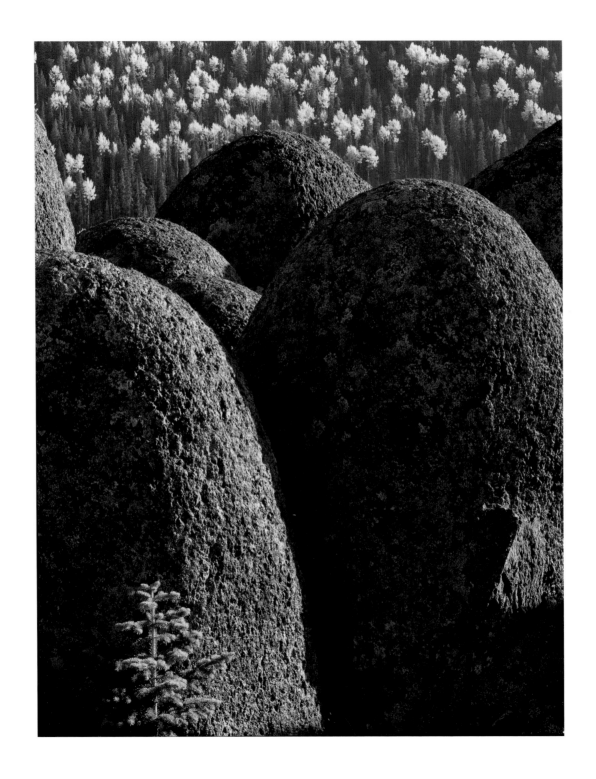

ROBERT G. McDONALD

SEPTEMBER 2000
4x5" FILM
WHITE MOUNTAINS

The details are what make this image wonderful. Robert McDonald said that making this photograph was a precarious endeavor — the position of the camera and his tripod made him a little nervous. Compositionally, the pine tree anchors the foreground, and it's tied to the mass of pine trees in the background. Take out the tree, and you still have a great image, but by leaving it in, McDonald gave the photo a little extra *oomph*.

"I was familiar with this area because I worked for the Forest Service in 1965. But when I searched the entire area looking for what I thought was the best foreground, this scene, by far, appeared to me to be the most intriguing."

— ROBERT G. McDONALD

ROBERT G. McDONALD

DECEMBER 2000
4x5" FILM
GRAND CANYON

The Grand Canyon can be overwhelming, so, when photograph-
ing it, it's often helpful to focus on something — in this case, the
tree — that would otherwise be more like a supporting actor.
That way, the Canyon becomes just a part of the scene.

"I camped out the night before, and fresh snow fell.
The next morning, sunlight was filtering through some
thin clouds, creating a pastel color that I found very
intriguing along the rim."

— ROBERT G. McDONALD

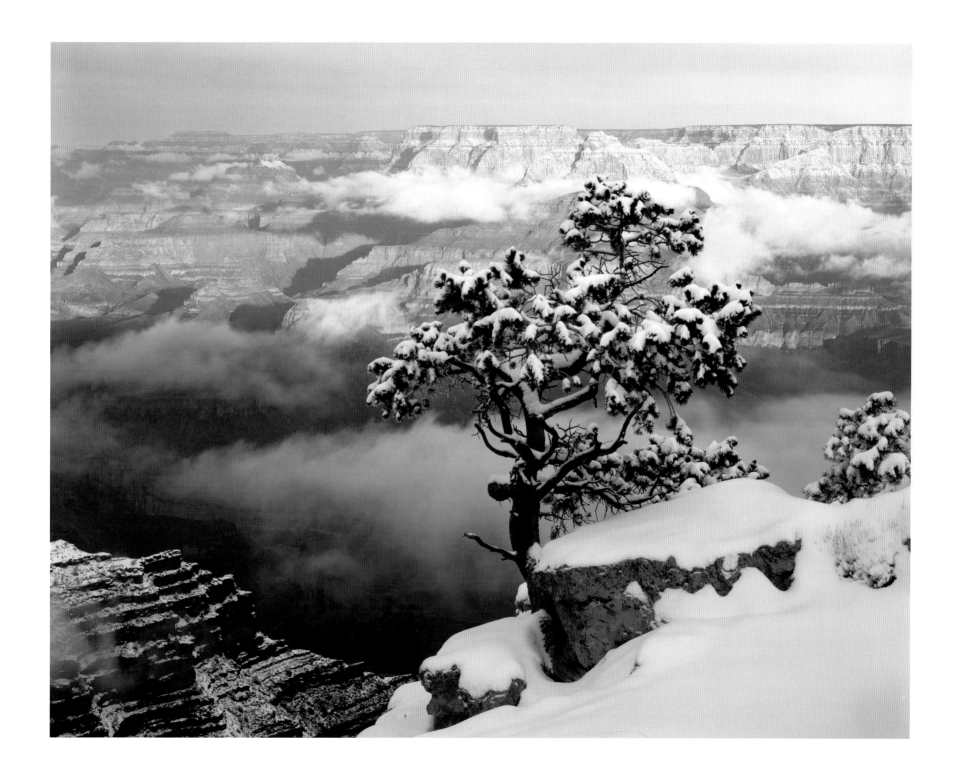

GEORGE STOCKING

DECEMBER 2000
4x5" FILM
SUPERSTITION MOUNTAINS

The color of the sky, coupled with the classic feel of this photograph, makes it extraordinary. It's reminiscent of an old Western painting. It's a sunrise shot, and the light is slightly filtered by the clouds, giving the sky a wonderful peach tone. Compositionally, it's absolutely sublime. George Stocking did his homework, and this photo is the payoff.

"I ran back down the trail to a cholla field I had previously scouted. I set up the 4x5 as fast as humanly possible and exposed three sheets before the light vanished."

— GEORGE STOCKING

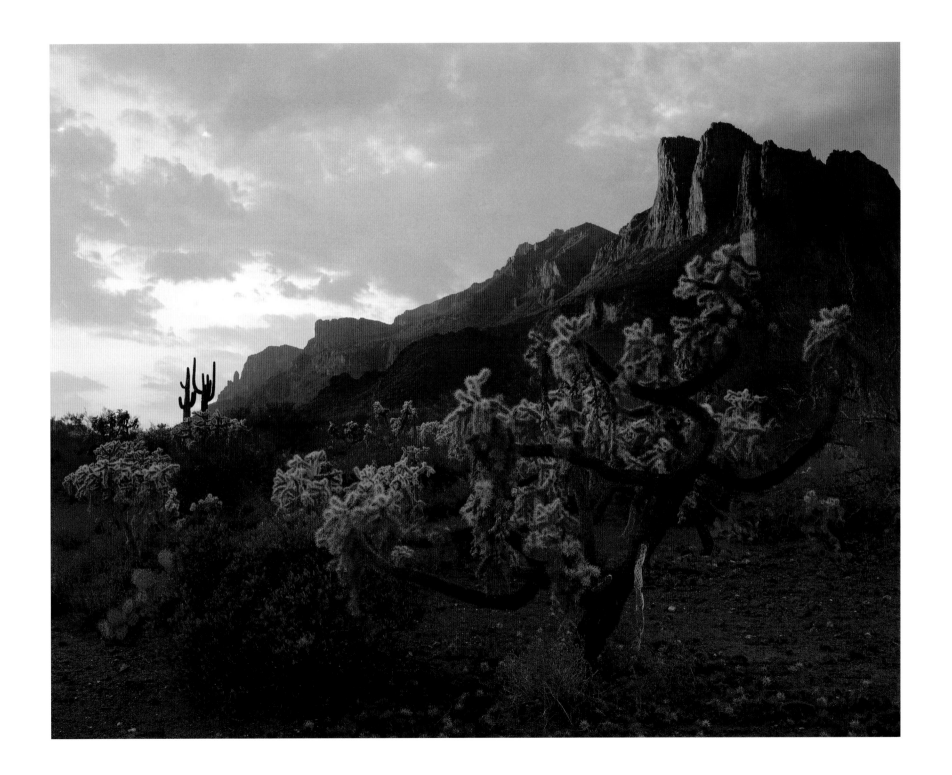

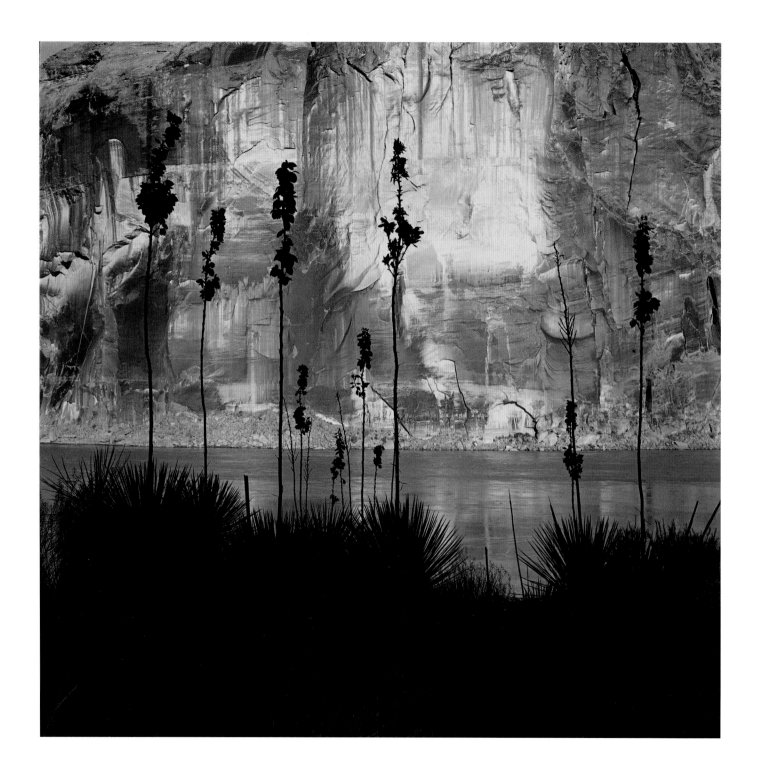

TAD NICHOLS

APRIL 2001
MEDIUM-FORMAT FILM
GLEN CANYON

This image turns the ordinary into the extraordinary. By exposing for the sunlit canyon wall, the plants go into silhouette, which is all they need. Other people might have tried to do more with this image, but Tad Nichols took it for what it was — beautiful, elegant, poetic.

"I was so intrigued with Glen Canyon and the beauty of it that every summer, for the next seven or eight years, I borrowed, begged or stole a boat and went into Glen Canyon. Every year, I would explore a different side canyon — each one was different and extraordinary. I never thought such a place could exist."

— TAD NICHOLS

JEFF SNYDER

AUGUST 2001
4x5" FILM
SALOME WILDERNESS

The image is all about shape and form. Jeff Snyder used the rock form and the striations that have been weathered over time to lead you down to this one little ripple. That's your payoff. It's a beautiful study in composition.

"The most challenging part was getting there — wading through the pools, rappelling down the cliffs and waterfalls — while carrying this heavy gear with me. I was standing in the water, waist deep, when I shot this photo."

— JEFF SNYDER

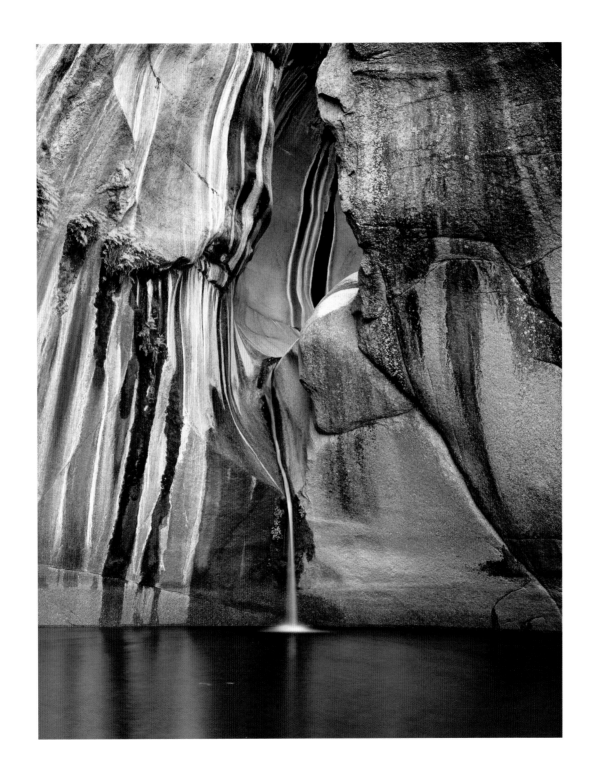

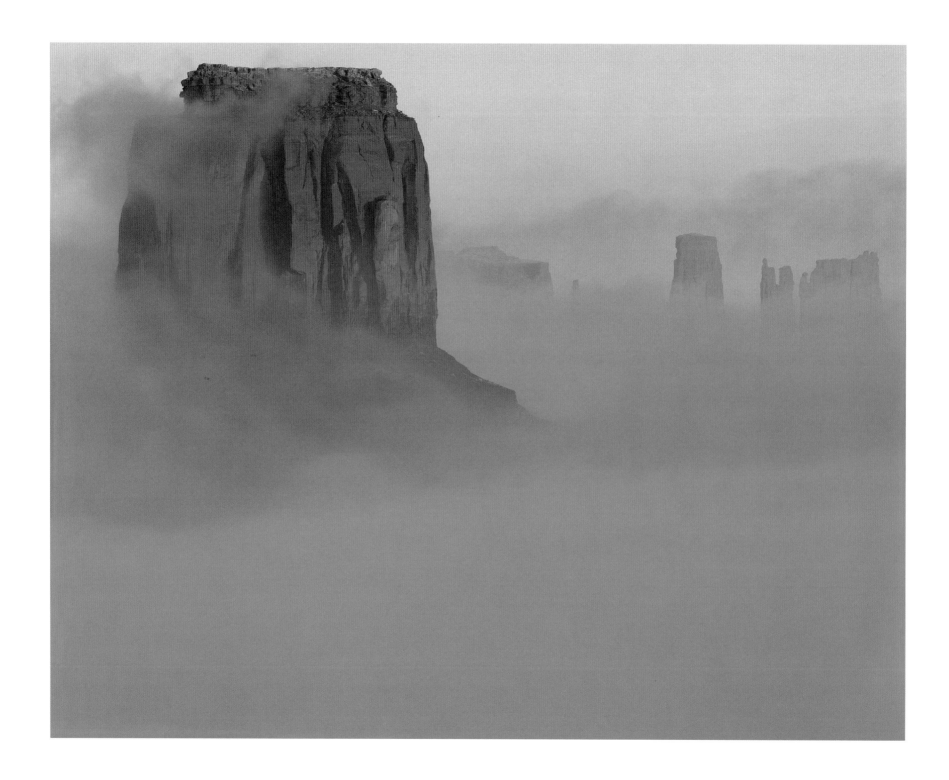

JACK DYKINGA

DECEMBER 2002
4x5" FILM
MONUMENT VALLEY

Land formations won't change, but weather conditions will. That's why photographers follow storms. Jack Dykinga is one of those people. This is a study in patience and planning, and when you put those two things together, something wonderful happens. The photo is otherworldly. It almost looks like the monoliths are floating in the mist.

"It was a matter of seeing the conditions and positioning myself to capture them. The best images are the ones that jump into your camera. They're ready to go, and it all comes together."

— JACK DYKINGA

DAVID MUENCH

DECEMBER 2002
4x5" FILM
GRAND CANYON

This image captures the spirit of a place that's greater than any other — the Grand Canyon. Many people would say you can't shoot into the sun, which is what David Muench did here. He used the horizon line and waited for the sun to peek out to create the starburst. When you're dealing with something as immense as the Grand Canyon, it's difficult to find the ideal camera angles — it often comes down to a game of inches. Muench took this massive landscape and captured its essence in this shot.

"Timing is key — everything is related to timing. When it's clear like this, you want to catch the sun either behind the trees or rocks, and avoid capturing the full sun, because you'll get flares."

— DAVID MUENCH

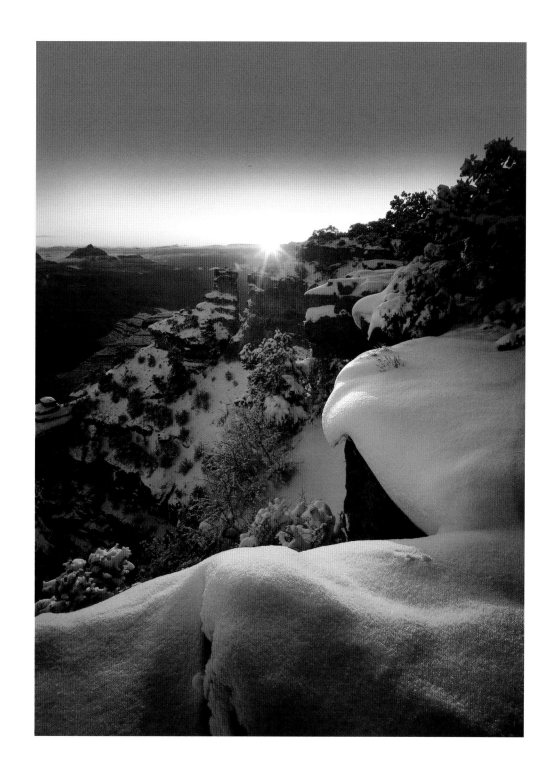

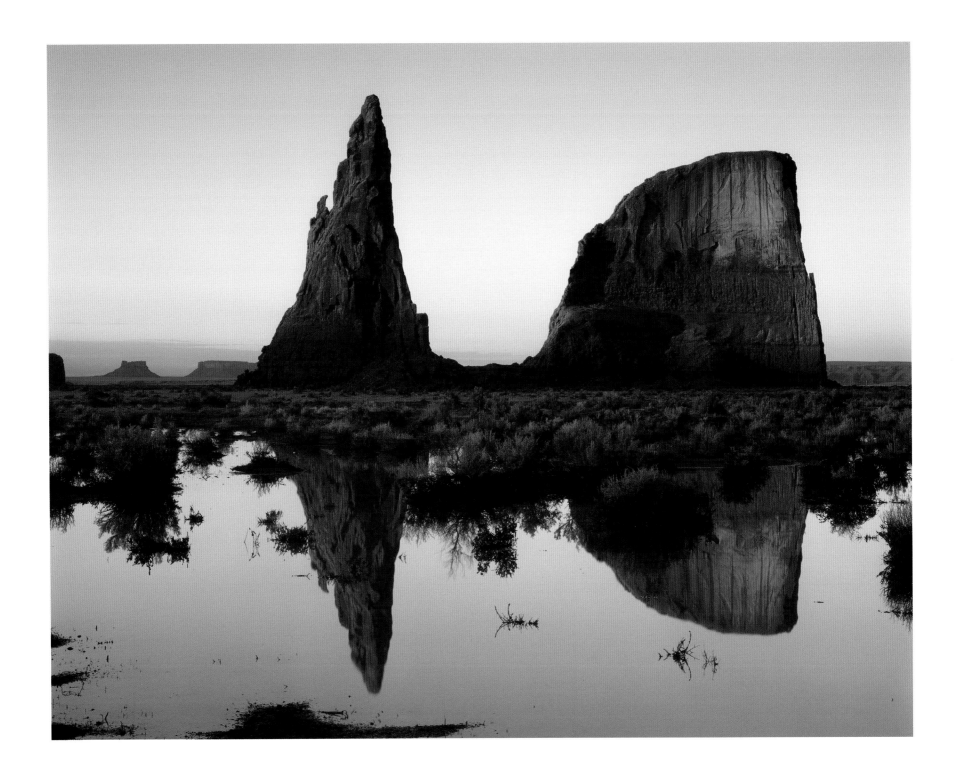

TOM TILL

APRIL 2003
4x5" FILM
LUKACHUKAI

Most photographs are the result of thoughtful planning. This image is one of the exceptions. The quiet reflection is pure magic. Everything is dead calm, and the air is clean. A monsoon created the puddle, and by looking at the surroundings, you can tell that the landscape doesn't often get rain. That's the great thing about photography — you can plan and plan, then a storm will come through and change your plans.

"I came through one summer day and was amazed at how much water there was — it's normally dry as a bone. I saw this huge reflecting pond, but it wasn't the right time, so I came back the next morning and shot it."

— TOM TILL

GARY LADD

JULY 2003
4x5" FILM
GRAND CANYON

Photographers, like other artists, often see the world in shades that others don't. This shot by Gary Ladd is a good example. Flagstaff artist Bruce Aiken likes to say that the Grand Canyon isn't red, it's blue. This photograph proves him right. No one has been as successful as Ladd in terms of capturing something like this. The Canyon was backlit, which gives the image photographic dimension, and the blue cast is a result of high humidity and smoke.

"The air mass had become so calm from the previous night, and the forest fire smoke had drifted down into the Canyon in orderly layers. At least for a while, the effect highlighted the maze of ridges and temples within the Canyon."

— GARY LADD

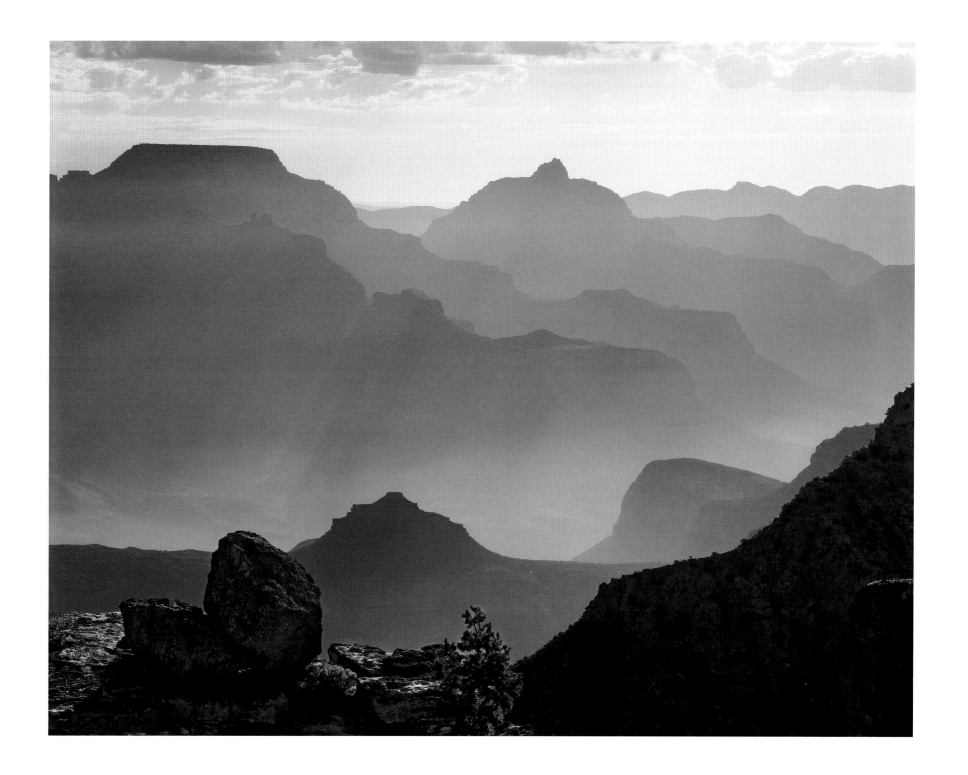

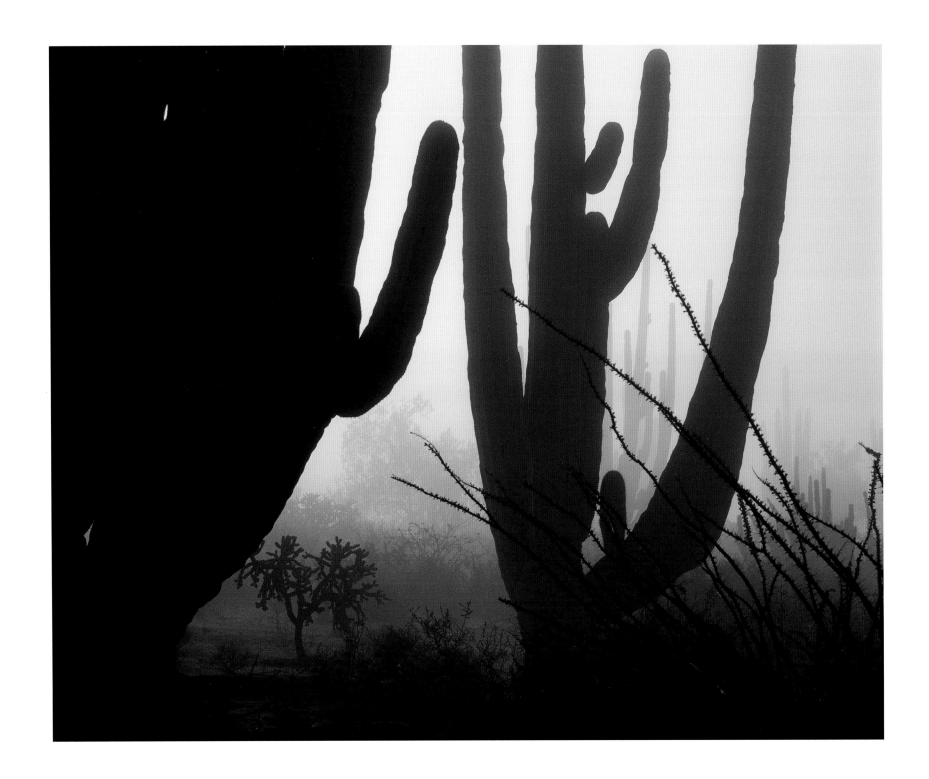

AUGUST 2003
4x5" FILM
MEXICO

This photograph appeared in a story about shell trading between ancient indigenous people in Northern Mexico, near the Gulf of California. It creates a wonderful sense of mystery. You're picking up the lost trail, which tells the story of the ancient people. There's a sense of depth and dimension even as the image recedes into the mist, thanks to the strong lines and the graphic forms.

"One night, it rained really hard, and though it eventually cleared, the temperature dropped. So, in the morning, instead of shooting the coast at low tide, I went to the ancient Cardon Forest outside town and waited for the fog to rise with the sun."

— GEORGE STOCKING

RICHARD MAACK

NOVEMBER 2003
4x5" FILM
MISSION SAN XAVIER DEL BAC

This photograph of Mission San Xavier del Bac presents a new perspective of something we've seen countless times. First, there's the magnificent scrollwork of San Xavier, which Richard Maack was able to capture because he gained access to the roof. Then, there's a beautiful graphic quality to it, which leads your eye from the foreground to the bell tower. Finally, there's the color. The yellow from the sunset is juxtaposed against the cobalt blue of the sky. It immediately grabs your attention. It's dynamic.

"I often return [to the Mission] when I need to remember why I love photography as much as I do. The way the light hits San Xavier del Bac is constantly changing — it's starkly beautiful and always a revelation."

— RICHARD MAACK

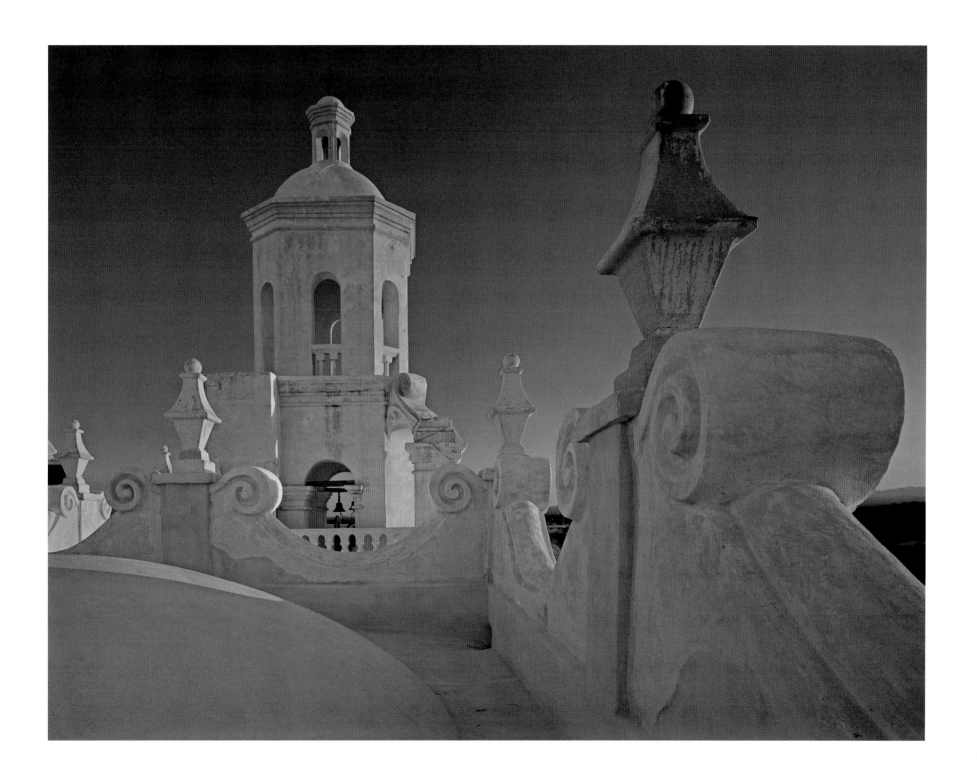

GARY LADD

DECEMBER 2003
4x5" FILM
GRAND CANYON

The interplay of light and texture in this photograph makes it one of the best of the best. Gary Ladd uses side light to emphasize texture. Your eye moves from the flowers in the foreground up and along the ridgeline. It's almost mathematical in terms of the way he composed the image.

"This photograph and two other fine images were made during a visit to the Grand Canyon's North Rim. It is exceedingly unusual to find three great scenes during a single trip."

— GARY LADD

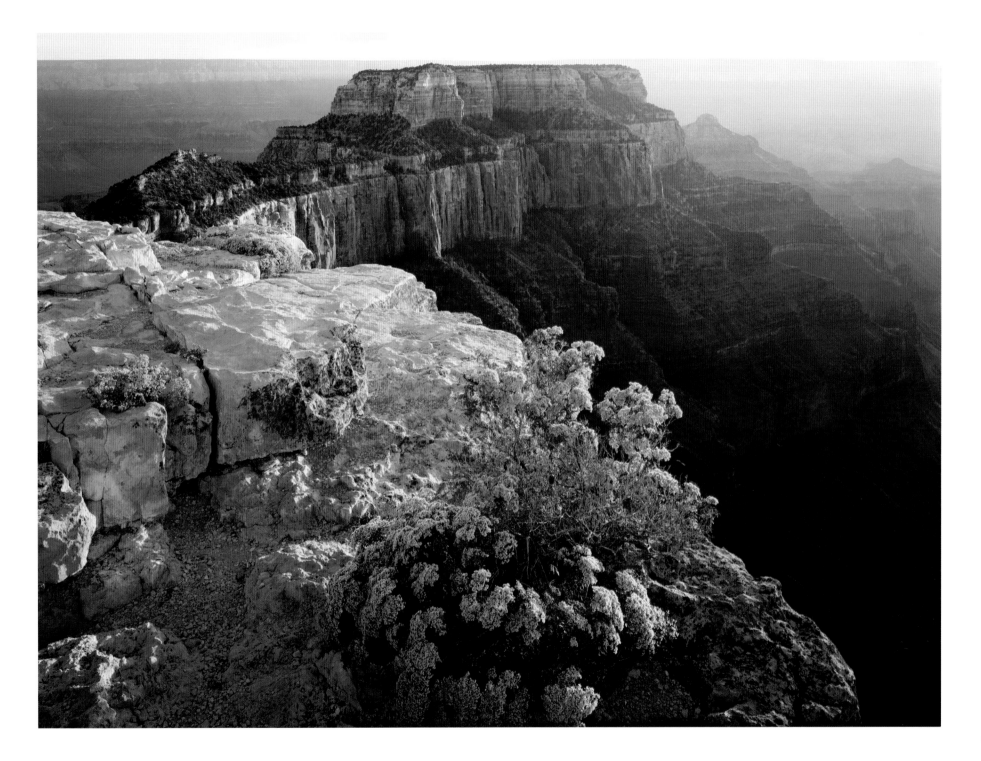

GEORGE STOCKING

DECEMBER 2003
4x5" FILM
GRAND CANYON

The light and shadows created by the breaks in the clouds add to the drama of this photo. Once the skies opened up, and the sun's rays poured down onto the landscape, the light created a wonderful stairstep effect, which leads your eye through the frame.

"My tripod was perched precariously on the edge of the endless abyss. As the Grand Canyon slowly revealed her true essence, I was able, in that eternal moment, to click the shutter just once."

— GEORGE STOCKING

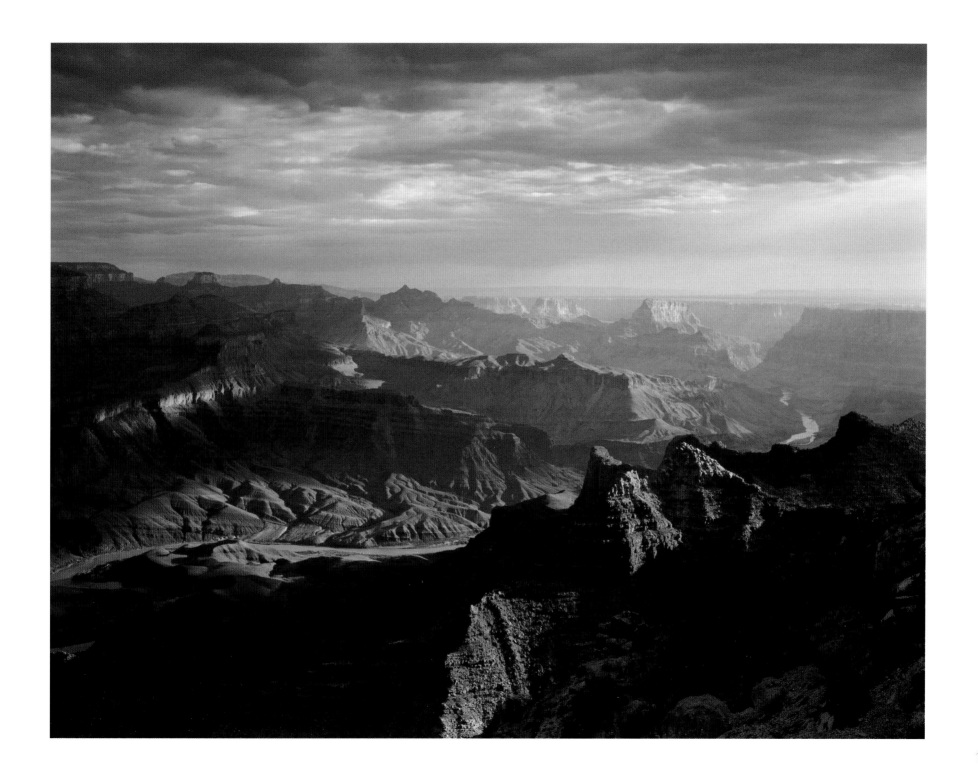

TOM VEZO

JANUARY 2004
35 MM FILM
COLORADO RIVER

This is an example of the "decisive moment." Tom Vezo captured this great egret as it was landing. You can actually see the wake as its wings are moving forward, creating a wonderful sense of anticipation — what will happen next? Besides capturing a moment, Vezo exposed the image so that only the bird would be revealed against an inky black background.

"I love to be out in the wilderness, enjoying all that nature has to offer, but it is the intimate encounters with wildlife that I treasure most."

— TOM VEZO, *Wings of Spring: Courtship, Nesting, and Fledging*

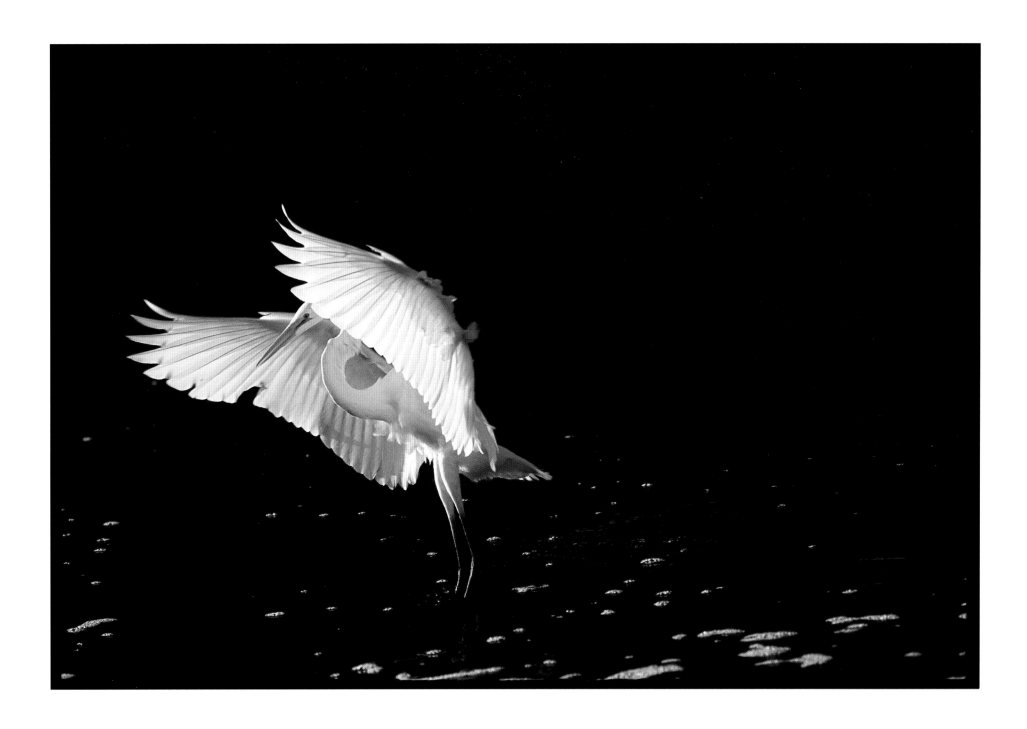

CHUCK LAWSEN

MAY 2006
4x5" FILM
HAVASUPAI RESERVATION

This photograph uses soft light and composition to perfectly illustrate a unique Arizona destination. Chuck Lawsen used the foreground to tell the story of how these circular travertine formations were made. The image takes your eye from the foreground all the way back to the pools, where you see the water source.

"I'd been out a couple times before, and the light wasn't the right hue. This time, this afternoon, it was a very warm light. The light bounced around the red walls, creating very good light."

— CHUCK LAWSEN

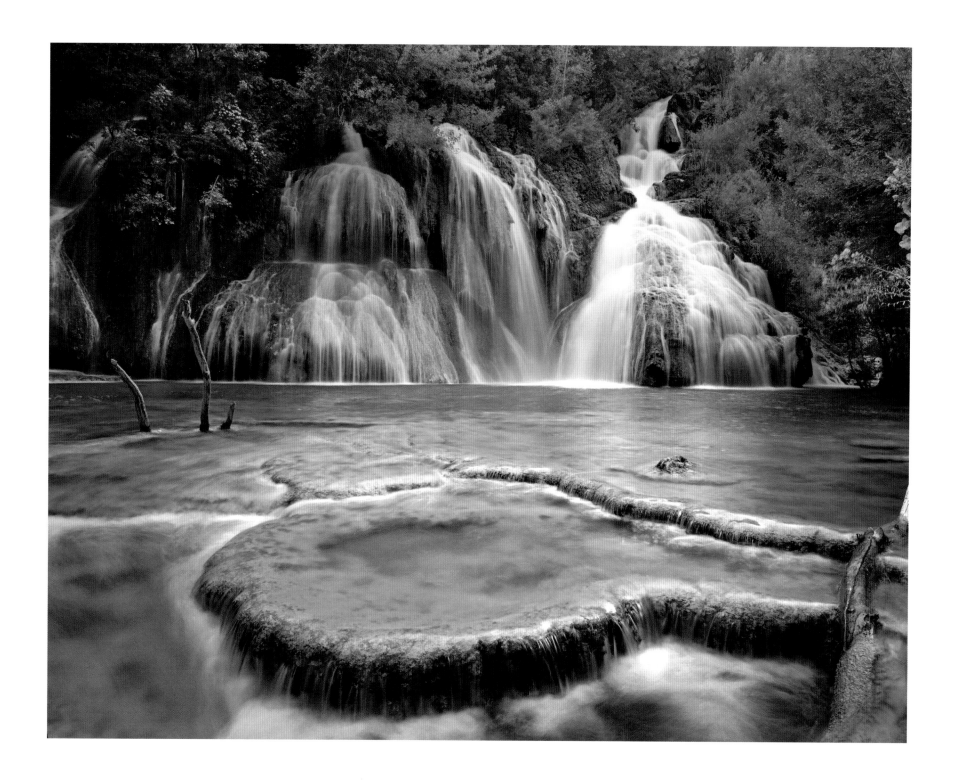

LeROY DeJOLIE

JUNE 2006
4x5" FILM
MONUMENT VALLEY

There's something very special about Monument Valley — there's a stillness to the place, and the stillness is overwhelming. Navajo photographer LeRoy DeJolie captured it by framing this image to allow the eye to quietly absorb the great vista up ahead.

"At the beginning and end of each day, the hues in the sky and clouds add dramatic interest, as in this photograph."

— LeROY DeJOLIE

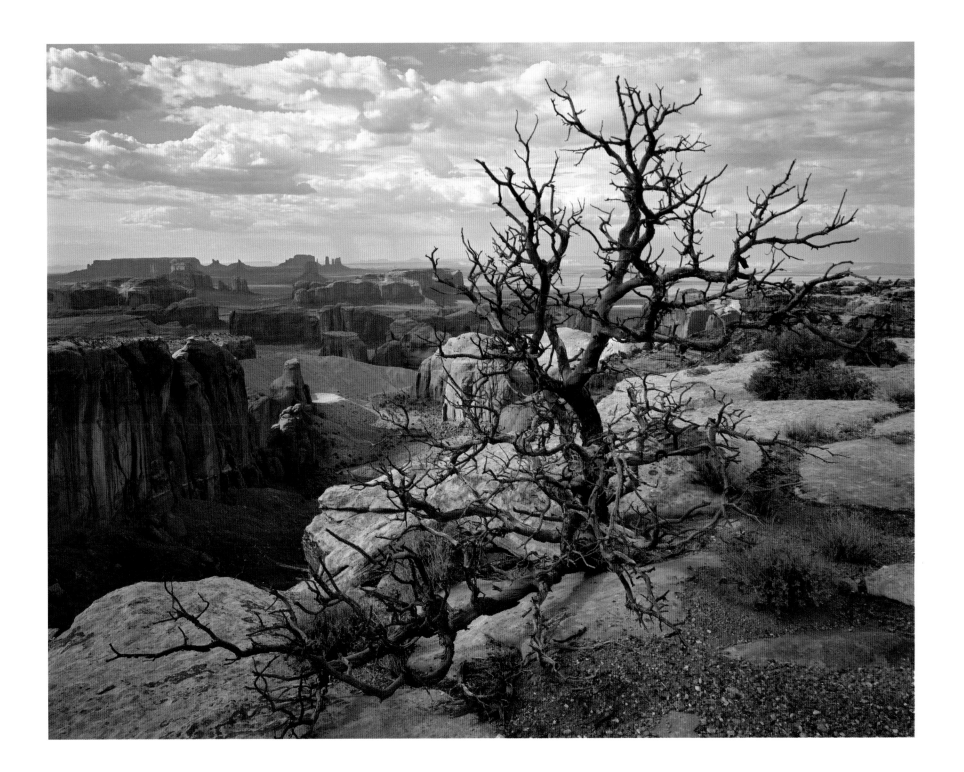

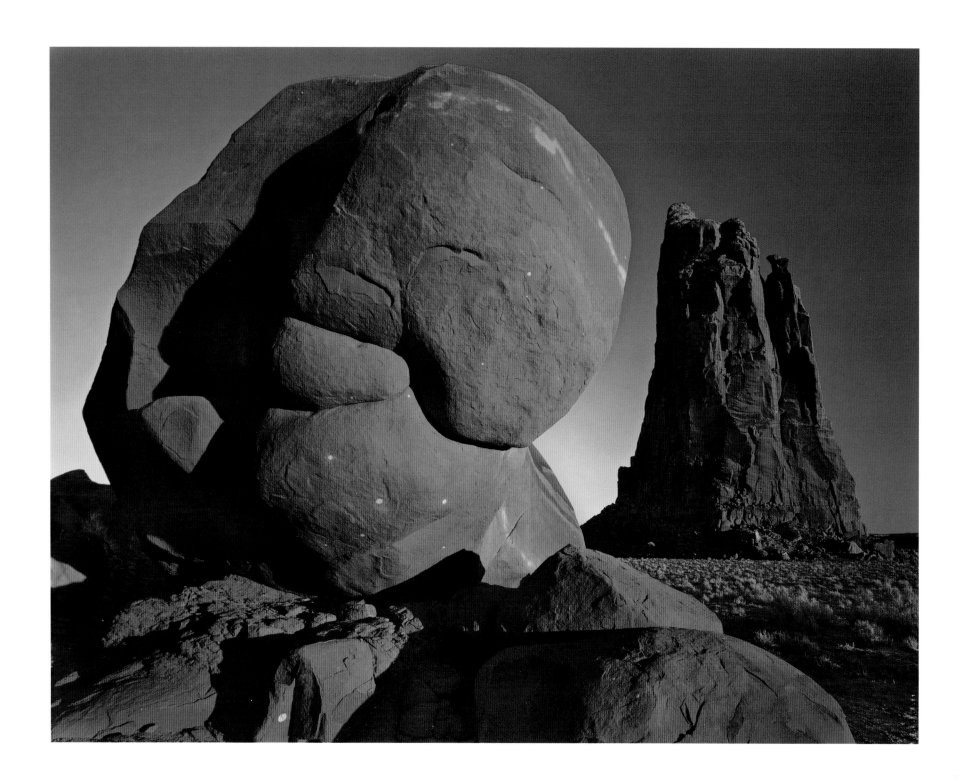

JACK DYKINGA

JULY 2006
4x5" FILM
LUKACHUKAI

This photograph captures the simple beauty of contrasts. The strong foreground contrasts with a powerful background. Then, in terms of the rock formations themselves, the smooth rocks are balanced against the jagged pinnacle. There's also a color contrast. Warm tones become even brighter against the unbelievably brilliant blue sky.

"I wanted to do something different, and it didn't quite work out, so this is the picture I got. What drew me to it were the contrast and shapes between the vertical spires and the rounded rocks."

— JACK DYKINGA

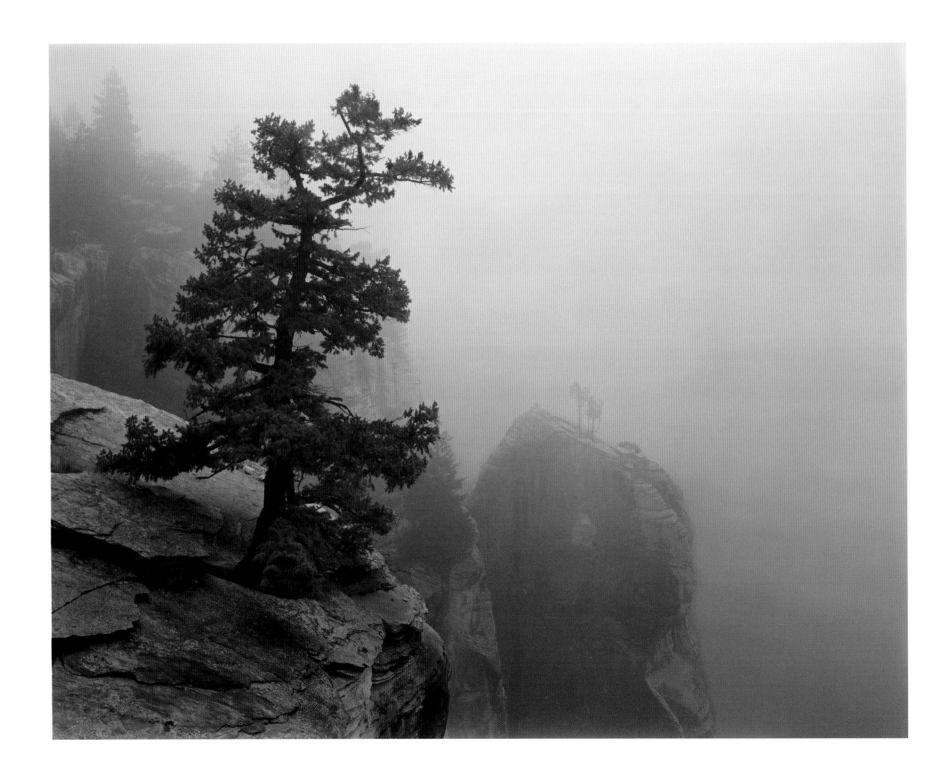

JACK DYKINGA

AUGUST 2006
4x5" FILM
GRAND CANYON

Mystery and beauty unite in this photograph, making it one of our favorite Grand Canyon images. It resembles Asian art, and you can't help but think, "What's behind those mists?" There's also a repeating pattern — you can see the pinnacle in the background with the small trees that mimic the tree in the foreground.

"It's one of those images that created a feeling of transcendence. When you have conditions like that, it becomes otherworldly."

— JACK DYKINGA

DAWN KISH

OCTOBER 2006
35 MM FILM
HOPI RESERVATION

Who sees like this? Had this child come up to any other photographer and thrown his hands up, they likely wouldn't have had the presence of mind to make the photograph. Dawn Kish did. She took the time to beautifully compose the shot, and the result is a wonderfully refreshing image of a boy being a boy.

"It's incredibly difficult to photograph the Hopi Reservation and the people who live there. They are very private, and I respect that. But, if you ask them directly — and not by the kivas — you might get lucky and become involved in a harvest day."

— DAWN KISH

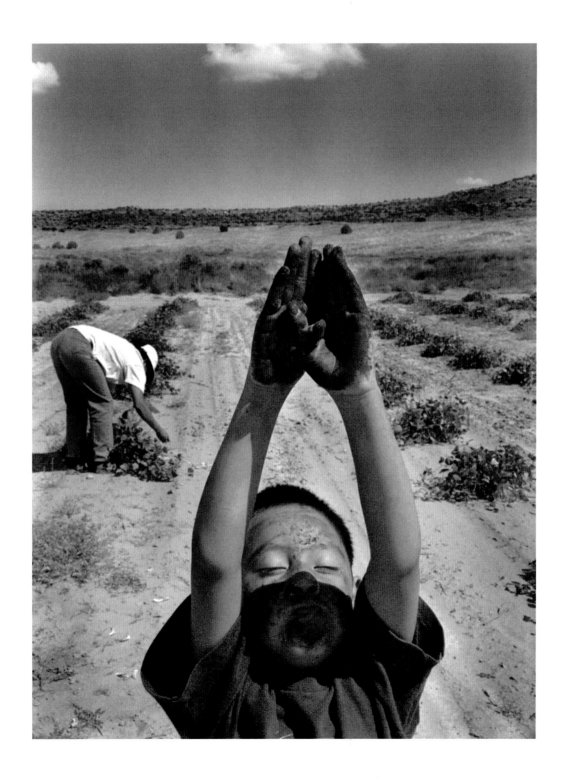

GEORGE H.H. HUEY

FEBRUARY 2007
MEDIUM-FORMAT FILM
CHACO CANYON, NEW MEXICO

Chaco Canyon isn't in Arizona, but this image ran as part of a story in the February 2007 issue of the magazine. George Huey used the great round form in the foreground to spin your eye out to the ruins in the background. It's like he's unraveling a spool using his camera.

"When I first glimpsed the sun breaking through the layer of fog, I knew the quality of light could be something very special, and it was — a warm glow was coming off my right shoulder, and there was this soft, blue fog in the distance."

— GEORGE H.H. HUEY

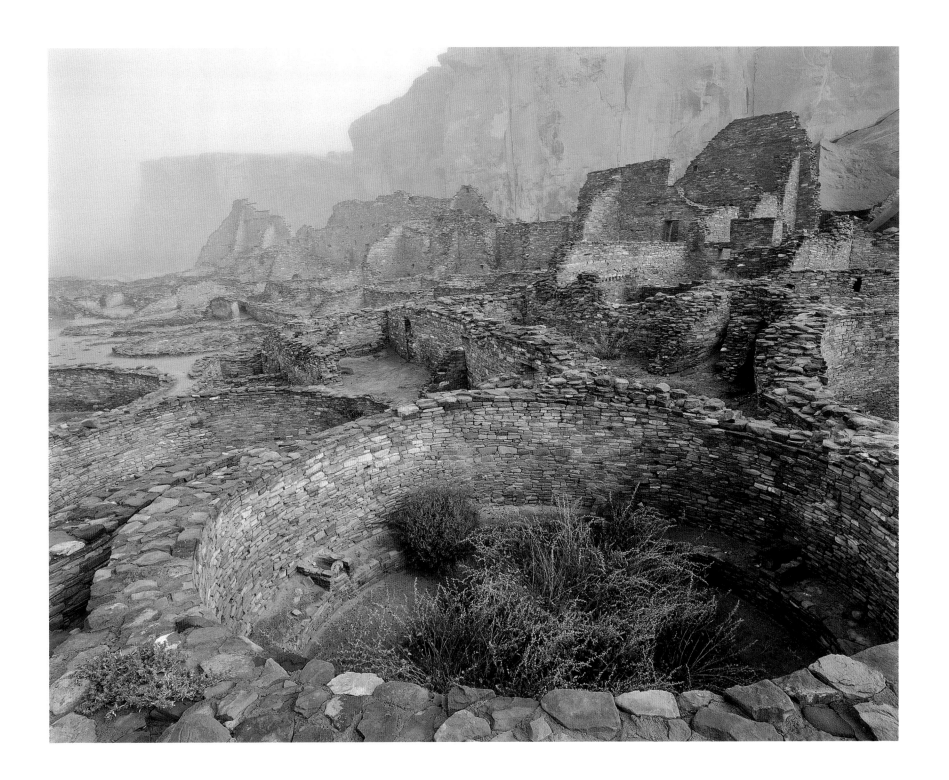

DAVID MUENCH

FEBRUARY 2007
4x5" FILM
CANYON DE CHELLY

This photograph creates a sense of anticipation because of how it's framed. David Muench waited for the shadow from the opposite canyon wall to creep up to the base of White House Ruin. It frames the ruin, but leaves the viewer with this question: "If I look away and look back, will the ruins be enveloped in shadow?"

"The shadow that delicately hits White House Ruin is what makes it for me — that shadow line is the key to this image."

— DAVID MUENCH

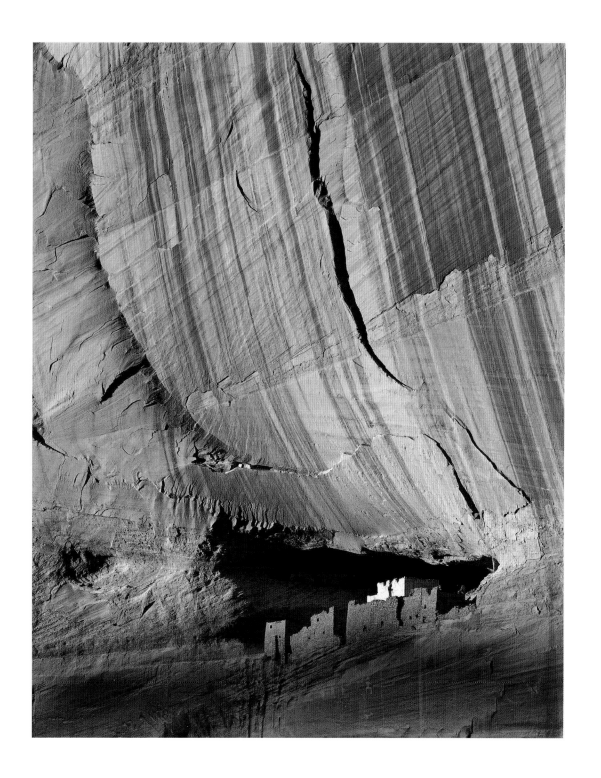

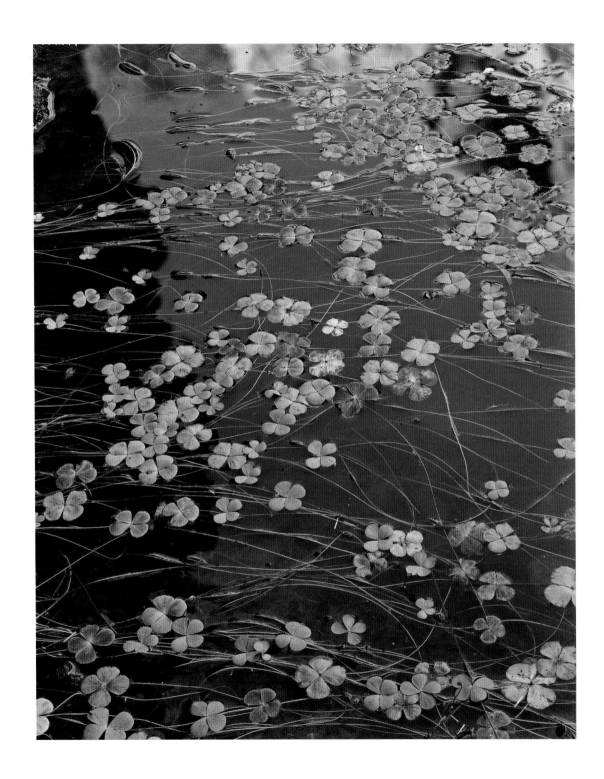

JACK DYKINGA

MAY 2007
4x5" FILM
PECK CANYON

Sometimes the best scenes are stumbled upon, as was the case with this photograph. Jack Dykinga came across this little pond in a side canyon. Using his 4x5 view camera, he was determined to keep the water shamrocks in focus. This is a pattern-and-texture shot. The warm, gold tones are contrasted against the blue sky that's reflected in the water.

"I really like this image now because it's more complex in composition. There's a subtle turn, and it involves selective focus."

— JACK DYKINGA

CLAIRE CURRAN

JANUARY 2008
4x5" FILM
CANYON DE CHELLY

Images of Arizona's most iconic landscapes abound, but only a few rise to the level of greatness. There are many photographs of Spider Rock from this vantage point, but this is one of the most interesting. Claire Curran used those sinewy, spidery twigs to frame the shot. Compositionally, she works you from the foreground, the middle ground and the great beyond.

"As I looked into the canyon at Spider Rock, I felt such a surge of joy and wonder. The world was snow white and sandstone red as the clouds ebbed and flowed. I spent the next three hours in complete solitude, looking at Spider Woman's world through my 4x5 camera."

— CLAIRE CURRAN

JEFF SNYDER

MARCH 2008
4x5" FILM
CABEZA PRIETA NATIONAL WILDLIFE REFUGE

Beauty blooms amid an otherwise rugged scene in this photograph. Jeff Snyder is a disciplined photographer, and he worked hard to find this grouping of flowers juxtaposed against the harshness of the mountains. He made this photograph in soft light, using a 4x5 view camera with a wide-angle lens. He also held depth of field from front to back, which required subtle adjustments to the camera.

"I looked out with binoculars, and I could tell there were some flowers. They were 3.5 miles from the road, but I hiked out there nonetheless. That field of flowers was probably the most spectacular scene I'd ever witnessed in Arizona."

— JEFF SNYDER

SEPTEMBER 2008
DIGITAL
SANTA CATALINA MOUNTAINS

In some cases, studio techniques can have a profound impact on what might otherwise be a standard landscape shot. That was the case with this image. Joel Grimes took studio strobes out into the desert because he wanted to augment the light. He wanted to highlight the cactus and the grass, which he did by hooking studio strobes up to a car battery. That required pre-visualization. That is, Grimes had to know how the shot was going to turn out before he even attempted to make it. He combined his background as a studio photographer with new landscape experience.

"I would spend hours roaming the back roads around Tucson looking for that perfect photo opportunity. I had driven by this saguaro hundreds of times, but my subject was patient, waiting well over a hundred years — long before I had ever picked up a camera — for me to claim my prize."

— JOEL GRIMES

TIM FITZHARRIS

MARCH 2009
MEDIUM-FORMAT FILM
OLIVER LEE MEMORIAL STATE PARK, NEW MEXICO

In this photograph, you see forms and textures. Tim Fitzharris framed the flower in such a way that your eye goes first to the little red blooms. The flowers are soft, yet sharp forms surround them. You see the spikes and spines of the agave. This photo is about simplicity and quiet beauty.

"The obvious contrast between the two plant types would draw anyone in for a closer look, especially a photographer. My task was to isolate and focus all the attention on this surprisingly harmonious relationship of colors, textures and shapes."

— TIM FITZHARRIS

WES TIMMERMAN

JUNE 2009
4x5" FILM
GRAND CANYON

Wes Timmerman came to the magazine with a portfolio about the Grand Canyon, and this was one of the images. He had a vision to photograph the Canyon using detail shots. Here, he uses the desert varnish and the lichen on the sandstone to create something really incredible. It's such a unique point of view, especially for a place that's so frequently photographed.

"The Grand Canyon lends itself to abstract photography in wonderful ways. Everything is enhanced by the reflective light, which does marvelous things to the light and shadows."

— WES TIMMERMAN

TED HENDY

OCTOBER 2009
DIGITAL
MONUMENT VALLEY

What impressed us most about this photograph was the amount of work and dedication it took to make it. Ted Hendy spent many hours consulting astronomical charts; this is actually a mathematical photograph. He had to predict when he would see the shadow of one mitten projected on the other mitten during a moonrise. When the time came, everything lined up for Hendy, including the weather.

"I used mapping skills that I learned from the Army and plotted where the moon was going to be and at what time. I thought, 'This might work.' It might have been another 30 years before the moon would be in that position again."

— TED HENDY

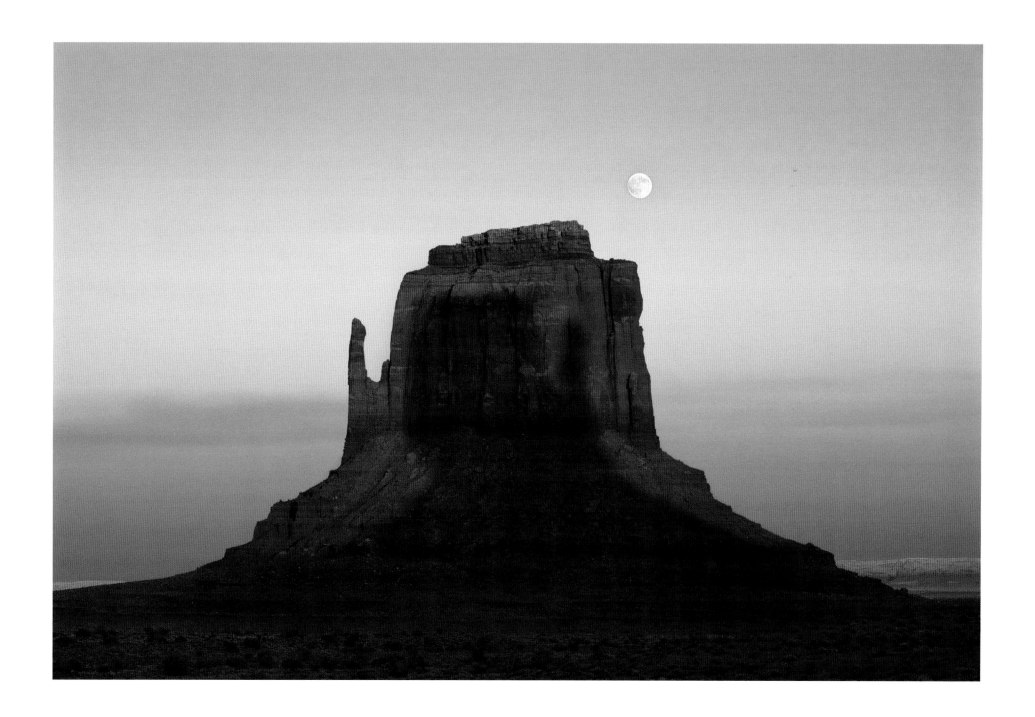

JACK DYKINGA

NOVEMBER 2009
4x5" FILM
SAN CARLOS APACHE NATION

His work may appear spontaneous or off the cuff, but Jack Dykinga rarely leaves anything to chance, making him a true master of his craft. Dykinga saw these trees as potential photos many times while driving through the San Carlos Apache Nation. While working on a grasslands project, he decided to commit to this location. When he arrived, he simply waited for favorable weather conditions. The rays of the sun create an immediate focal point, and the shadows and light on the backlit grasses naturally draw you in.

"I like to work with diagonals. The trick here is balancing the intense light of a setting sun behind this tree. You have to wait until it modulates and gets a bit dimmer, and then you can shoot it."

— JACK DYKINGA

SUZANNE MATHIA

DECEMBER 2009
DIGITAL
GRAND CANYON

This was Suzanne Mathia's first cover image for *Arizona Highways*. There's a wonderful glow surrounding the lone tree in the foreground. The clouds covering the Grand Canyon are opening up ever so slightly, and — boom — you have the payoff of the Canyon itself. There's a sense of anticipation in this photograph.

"Sometimes, when you stand in awe before an amazing spectacle such as this, the scene just envelops you. It's easy to melt into the landscape and become mesmerized and hypnotized."

— SUZANNE MATHIA

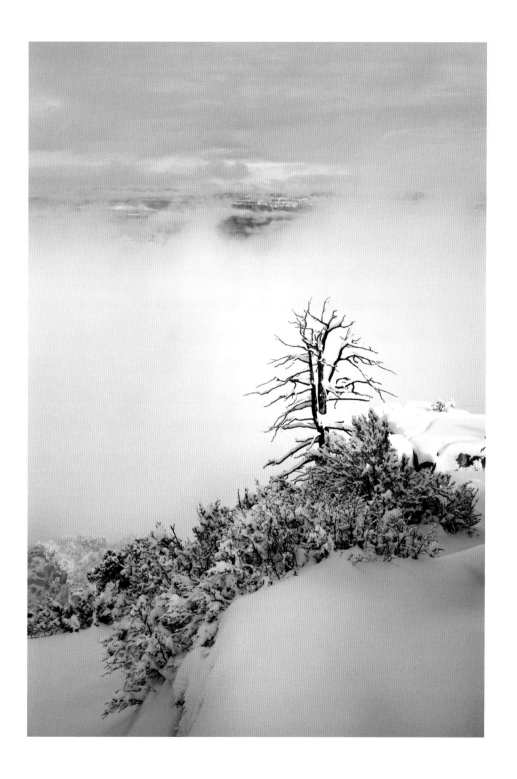

GARY LADD

DECEMBER 2009
4x5" FILM
LAKE POWELL

The small details in this photograph compelled us to return
to it again and again. The photograph keeps revealing itself.
The first thing you see is the sunrise, then the snow, and
as you look closely, you see the mists coming off the water.
The little details unfold.

"It snowed during that long winter night, but sunrise
turned out to be staggeringly dramatic. I couldn't take
4x5 camera images fast enough."

— GARY LADD

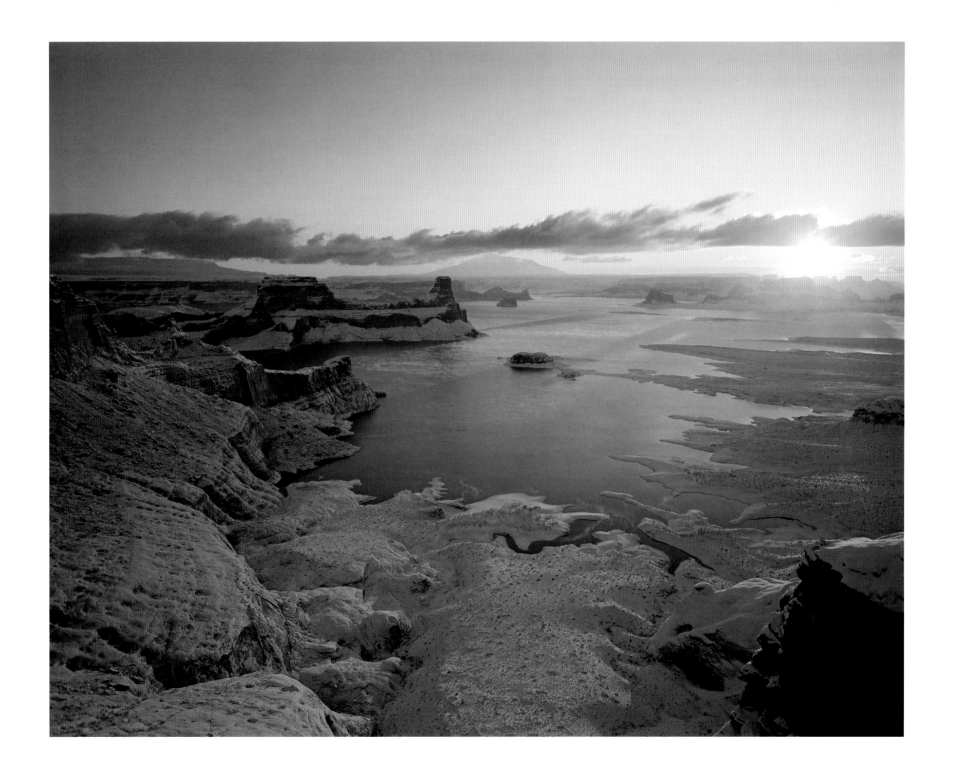

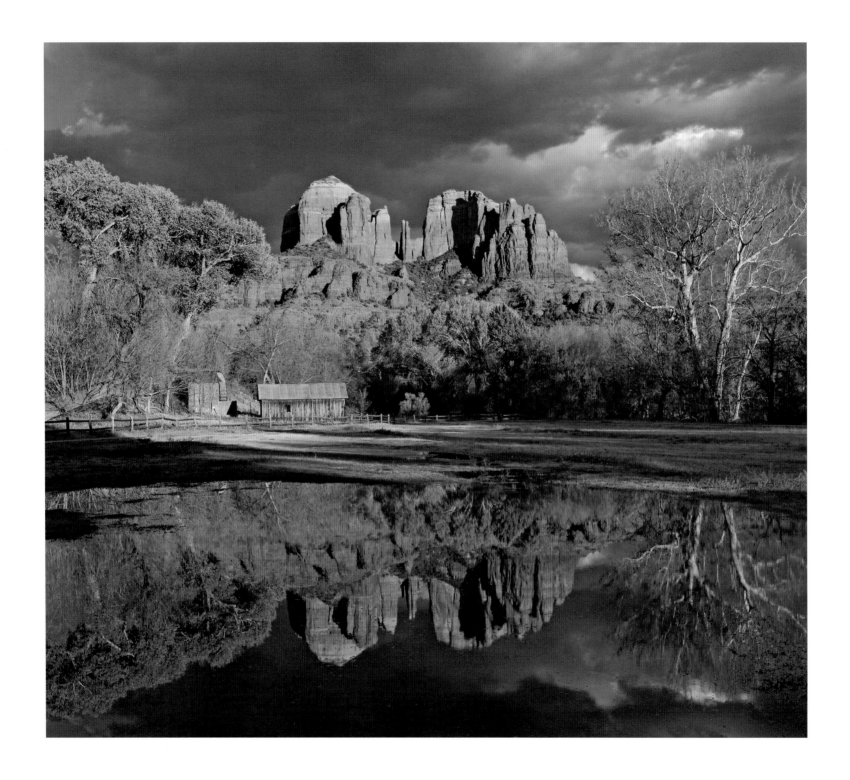

DEREK VON BRIESEN

DECEMBER 2009
DIGITAL
SEDONA

We see Cathedral Rock all the time, but none of us had ever seen a photo like this. There was a huge rainstorm, and the rain came down hard and fast. Then the skies opened up and the sun came out. Derek Von Briesen had late-afternoon light to work with, and he captured this shot with that wonderful reflection.

"The clouds darkened behind Cathedral Rock, and the sun peeked out from under the clouds in the west — that's always the magic cue."

— DEREK VON BRIESEN

JACK DYKINGA

JANUARY 2010
4x5" FILM
PARIA CANYON

Jack Dykinga backpacked to this site six different times to get this shot. On some trips, there was too much water or too little water, but he saw the potential. Look at the reflection — you can see the sun hitting the top of the peak — and the lines lead your eye right to the focal point of the image.

"I shot this several different times, and on my last attempt, I drove through the night, so I could start hiking at 3 a.m. or 4 a.m., in order to arrive by dawn. Not only was the water completely calm, the twisted branch was there. The harder you work, the luckier you get."

— JACK DYKINGA

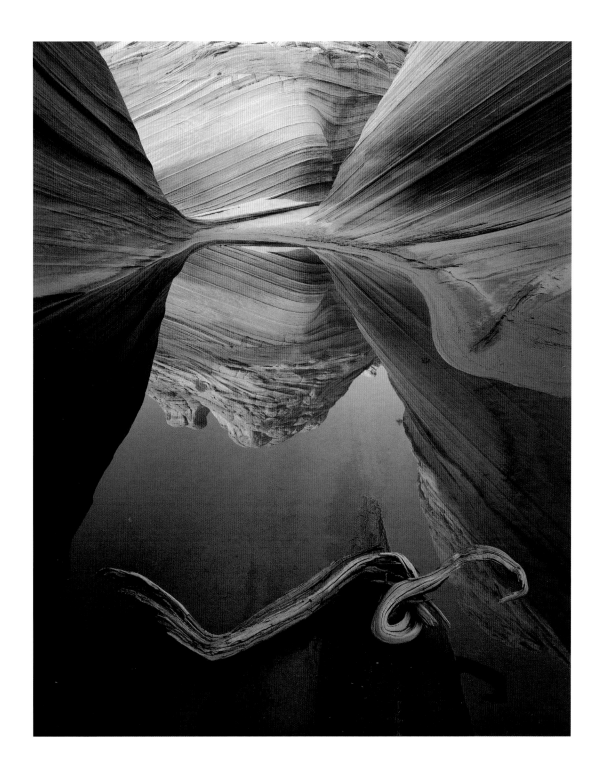

RANDY PRENTICE

FEBRUARY 2010
4x5" FILM
WHETSTONE MOUNTAINS

Persistence paid off when it came to making this photograph. These century plants are on private property, yet Randy Prentice saw the potential and kept going back until he finally got permission to shoot. There's a graphic, soothing quality to the shot because of the pastel colors. This is an example of getting people to understand your vision, of getting them to see what you want them to see.

"A last-light scene like this is fleeting. The challenge is finding the right composition, getting the camera set up and exposing the film before it all goes away."

— RANDY PRENTICE

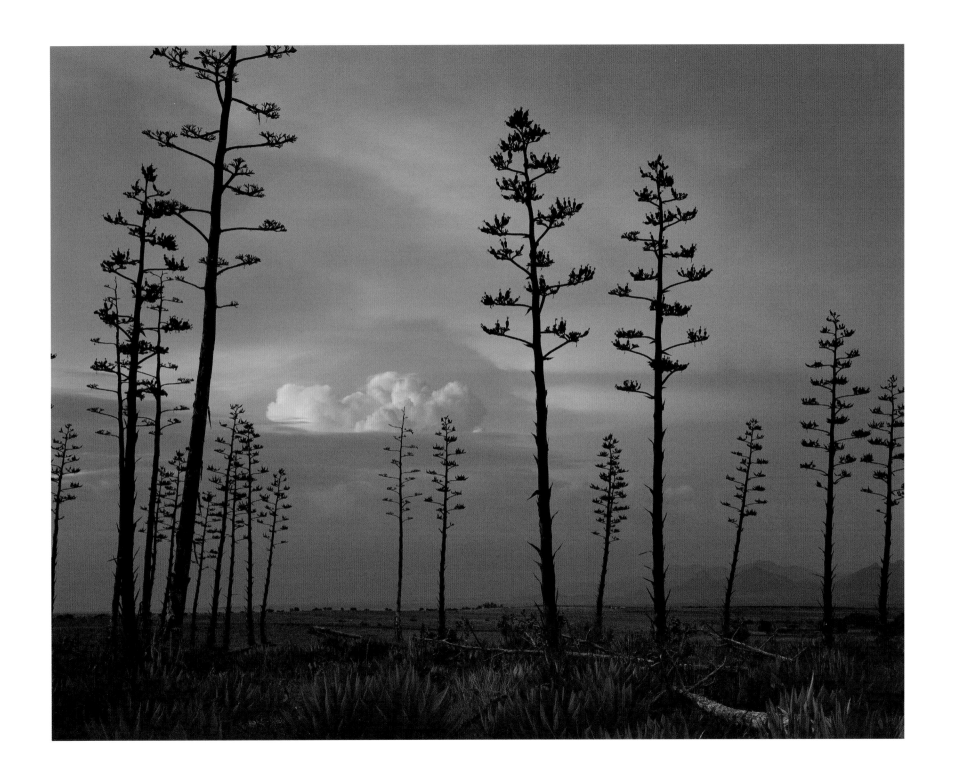

RANDY PRENTICE

FEBRUARY 2010
4x5" FILM
MADERA CANYON

The first word that came to mind when we tried to describe this photograph was "glorious." This is what happens when you're a good photographer and you wait. This was taken late in the day, when the sun was probably below the horizon. The clouds opened up, and the sun burst through and created a dome of illumination. It's glorious light.

"It was getting quite dark, and I considered leaving, when, without warning, red, pink and orange began pouring into the sky. It was all there in front of me. To this day, I have never experienced a sunset event as intense as this one."

— RANDY PRENTICE

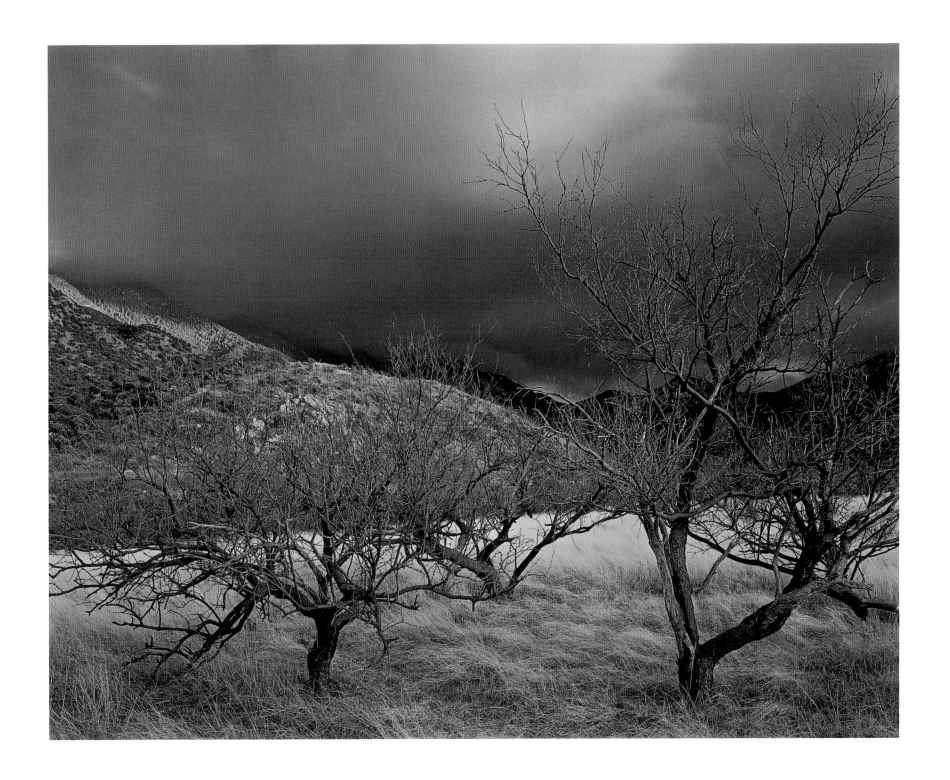

GARY LADD

MAY 2010
4x5" FILM
GRAND CANYON

This photograph stands out because of its composition and its simple beauty. The image is all about weather and color. Ladd was up on the hill waiting for things to open up, and then he got this break. The warm tones of the Canyon walls are offset by the coolness of the river. In terms of photo composition, Ladd used the river to lead you back, prompting you to ask, "What's next?"

"Thunder echoed up and down the canyon corridor, and one of the river guides urged us to head down to the boats. Some of us delayed our departure to take advantage of the magnificent storm scene that was unfolding."

— GARY LADD

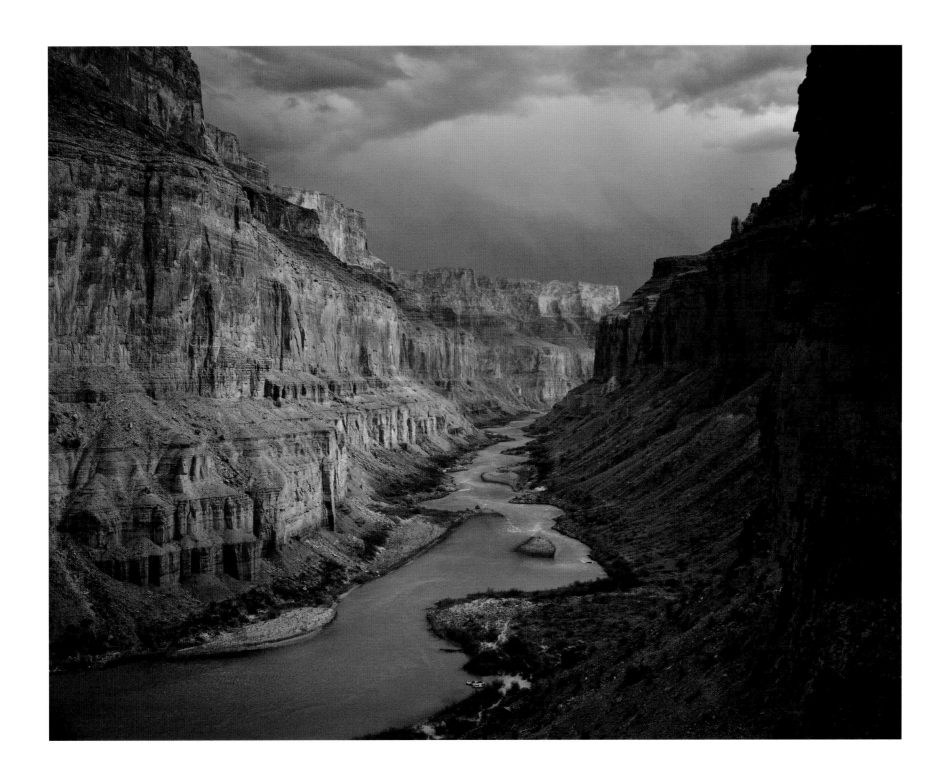

JACK DYKINGA

MAY 2010
4x5" FILM
GRAND CANYON

All of the components of this image seem to fall into place. Everything in the shot is where Jack Dykinga wanted it to be. There's a yin and yang in terms of color — from the turquoise blue to the reddish-gold rocks. Dykinga used the line created by the rocks in the background to direct your eyes to the reflection in the water. And in the foreground, he tells a story about the rocks in the water, which, when you follow them, guide your eye to the background.

"We were on the other side of the river and crossed early in the morning when, suddenly, the sun started illuminating the cliffs. There was a cloud layer that gave us a golden band of light for only a few minutes, and then it went away."

— JACK DYKINGA

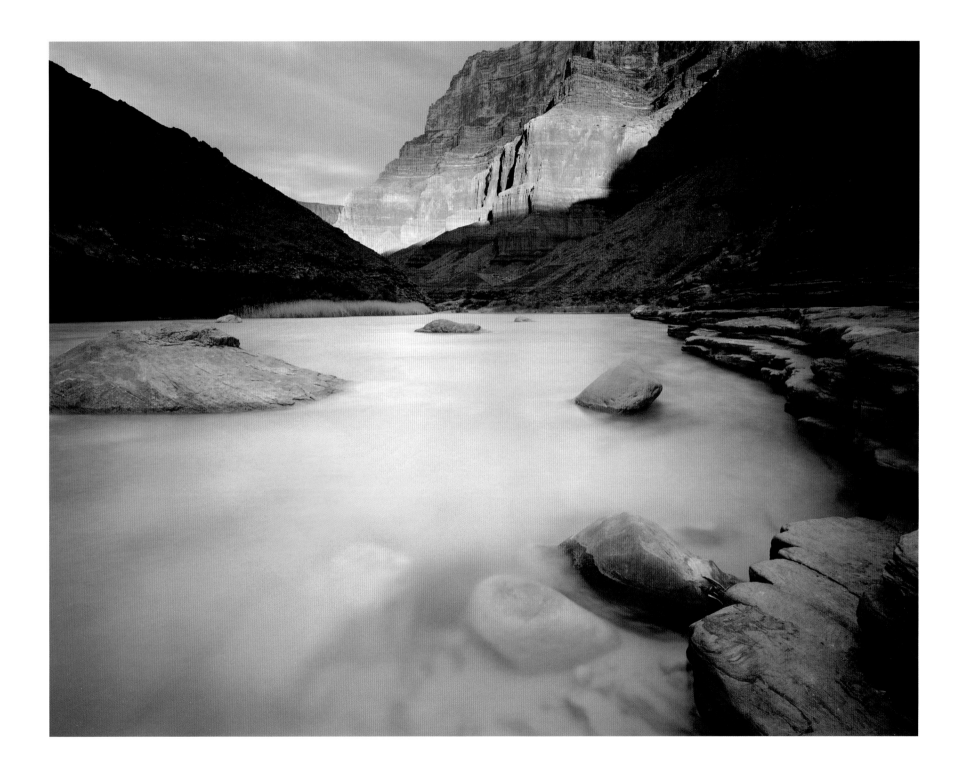

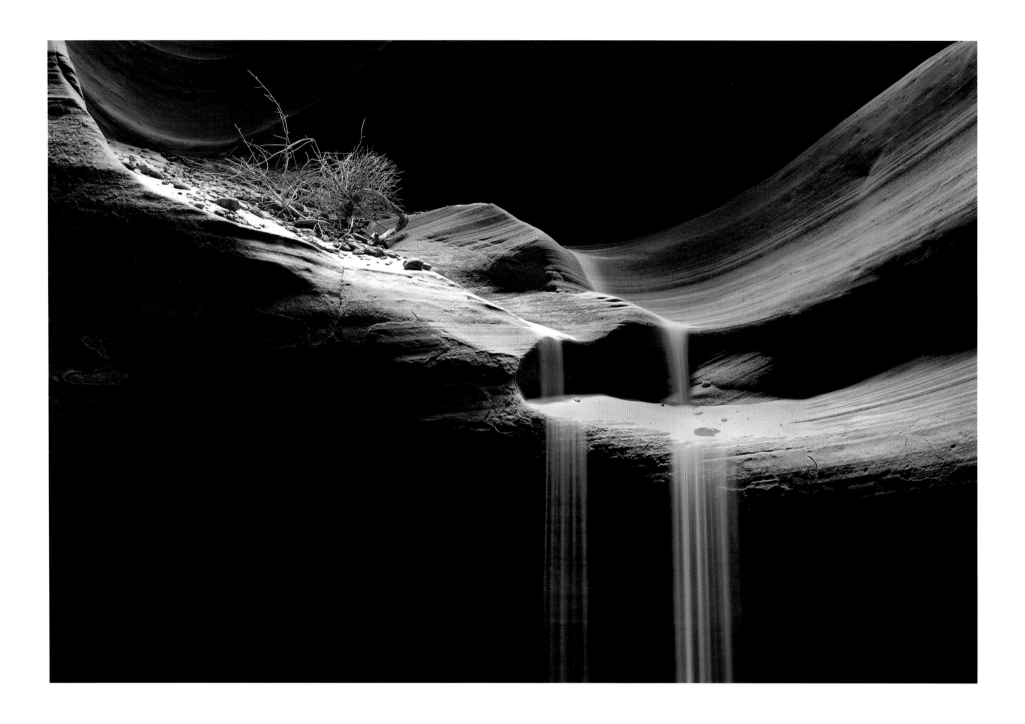

CHIKKU BAIJU

SEPTEMBER 2010
DIGITAL
ANTELOPE CANYON

This photograph provides a new perspective on a commonly photographed landscape. Chikku Baiju was the winner of our 2009 photo contest. He was 18 when he won, and as you can see, he has a gift. For this image, he saw shape and form. He used wonderful lines to lead you to the pouring sand. There's also a scraggly bush in the corner. Without the bush, the image would be too perfect.

"The first time [I visited the site], there were a lot of people, so I couldn't get something unique. That's one of my main goals: I want something different from the popular areas. Whenever I go somewhere, I do a little research and see what other people have taken. Then, I try and do something different."

— CHIKKU BAIJU

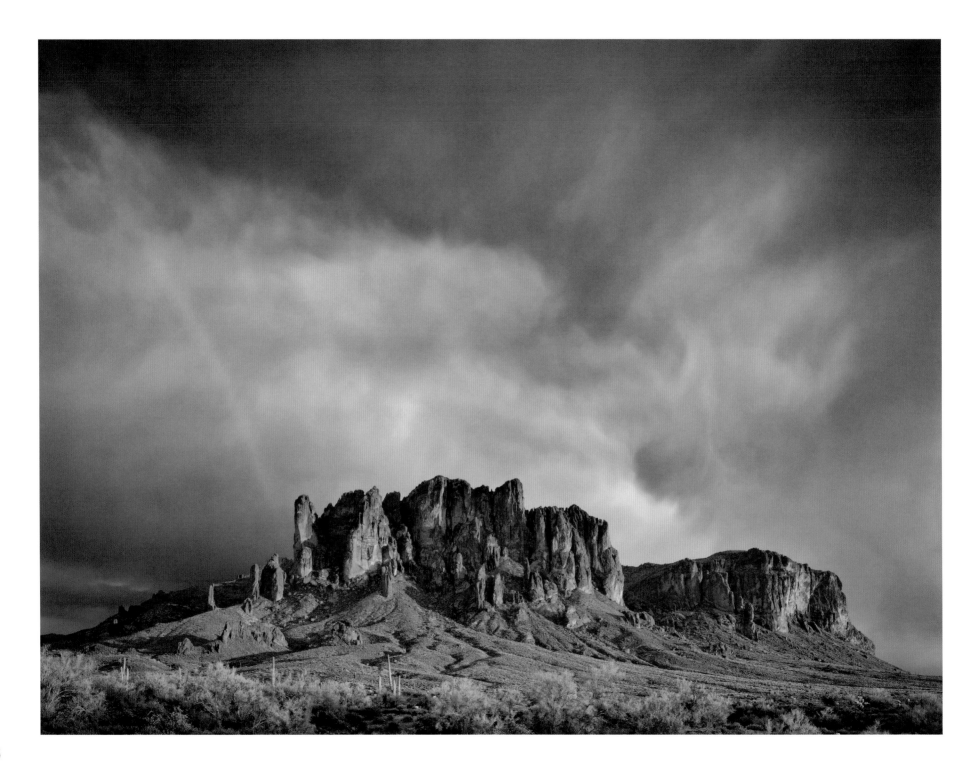

LONNA TUCKER

DECEMBER 2010
DIGITAL
SUPERSTITION MOUNTAINS

Hands down, this is one of the best shots we've ever seen of the Superstition Mountains. Lonna Tucker is a force to be reckoned with. Of all of our photographers, she's physically one of the smallest, but she uses the biggest digital camera. Tucker waited patiently for this shot and juxtaposed the harshness of the Superstitions against the clouds.

"Even though it was still raining, I set up a short distance down the trail and captured this image of the dramatic, clearing storm and last light on the Superstition Mountains. Patience, planning and experience paid off."

— LONNA TUCKER

SHANE McDERMOTT

DECEMBER 2010
DIGITAL
GRAND FALLS

In this case, the use of new technology turned what might have been an ordinary photograph into an extraordinary piece of art. Shane McDermott uses the latest digital technology, which is great in low light. He used a 30-second exposure with a Nikon D3 and a 17 mm lens at f/2.8. If you look closely at the stars, you can see a little bit of movement. The pinks peeking out over the horizon also add something to the image. It's amazing.

"It was the very last light, the stars were out and the clouds were illuminated. I wasn't planning on doing the starlight shot that night, I was planning it for two weeks later, but the right conditions came together."

— SHANE McDERMOTT

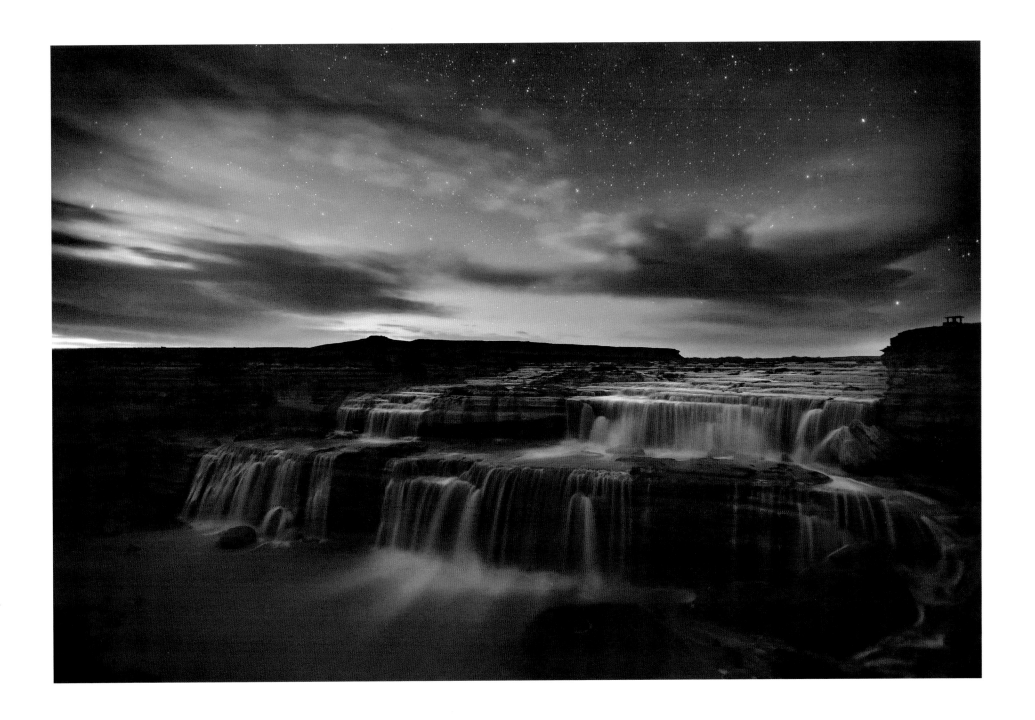

SUZANNE MATHIA

DECEMBER 2010
DIGITAL
OAK CREEK CANYON

The abstract quality of this photograph is what makes it special. The image is a little disconcerting; it makes you stop. This is pure art, yet it asks, "What's going on here?" Suzanne Mathia used a telephoto lens, so there's some compression going on. The rocks are in focus, and you have a slightly blurred reflection of the trees.

"While taking a break during a busy autumn shoot at Oak Creek Canyon in Sedona, I stopped to rest for a while along the creek. The pool reflected the canopy of color overhead, painting these colors, shapes and light right before me."

— SUZANNE MATHIA

GEORGE STOCKING

DECEMBER 2010
DIGITAL
MOGOLLON RIM

This photograph is a study in light and dark. George Stocking
chose to use backlight, which illuminates the white poppies.
He's created a wonderful separation that helps guide you
through the image. The mist in the background becomes a
veil, creating texture and depth.

"After watching a steady pattern of monsoon rainfall in the
area for about three weeks, I went to the Rim expecting
poppies — needless to say, I was pleased to see that they
were there in proliferation. Better than I had dared imagine."

— GEORGE STOCKING

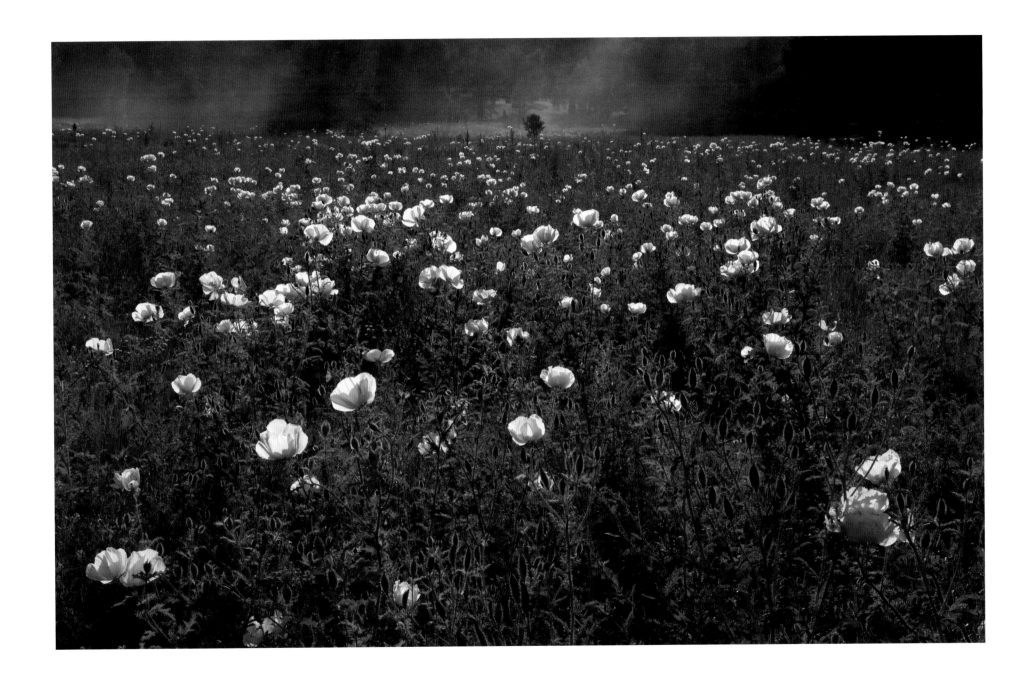

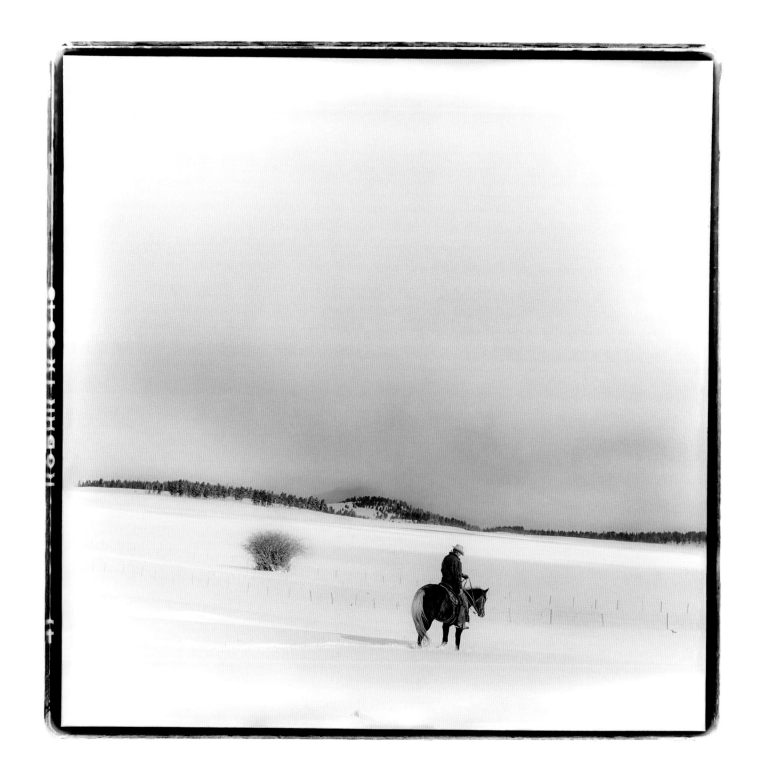

SCOTT BAXTER

FEBRUARY 2011
MEDIUM-FORMAT FILM
WHITE MOUNTAINS

Subtlety speaks volumes in this image. The horizon, the gray clouds, the spikes of grass, the snow, the cowboy looking down … everything is quiet. The image speaks to solitude. Scott Baxter didn't center the cowboy, but rather placed him to the right of the frame. It begs the question, "What is he thinking?" It's perfection.

"It was real quiet — that kind of quietness you get when there's snow — and a storm had passed. We didn't talk about it, plan it or decide where it was going to be; he just got on the horse and started checking the fence."

— SCOTT BAXTER

JACK DYKINGA

FEBRUARY 2011
DIGITAL
PINAL PIONEER PARKWAY

This image came out of a photo essay that was intended to be about water in the desert. Unfortunately, Jack Dykinga was working during a very dry year, so all of his images were brown and orange — there was no water. We needed contrast — cooler tones — for the portfolio, so Dykinga accepted the challenge and shot these yuccas by moonlight. He used a 10-second exposure, which provides the magical carpet of stars.

"This photograph represents a seismic shift in my work — I was getting into digital photography. In order to maintain the high quality, I stitched the image together."

— JACK DYKINGA

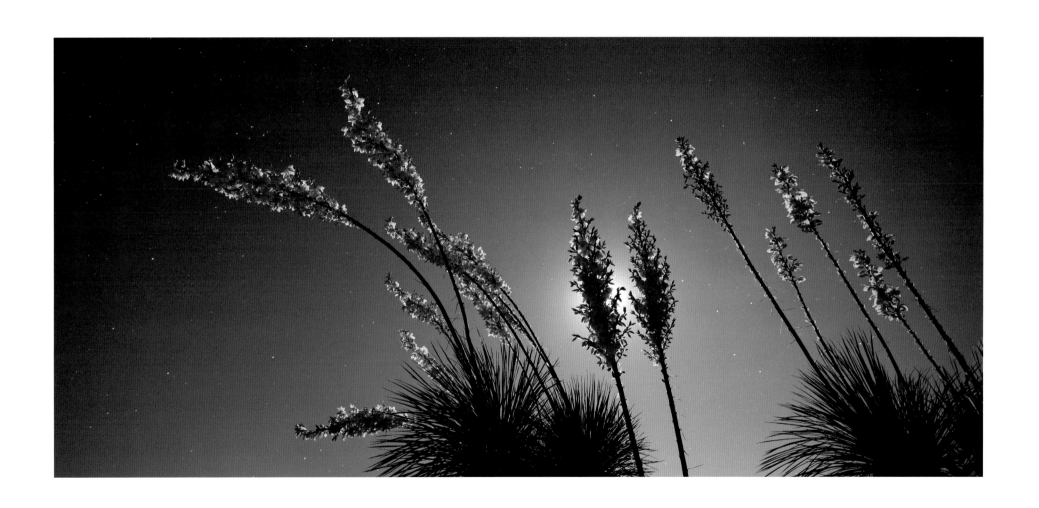

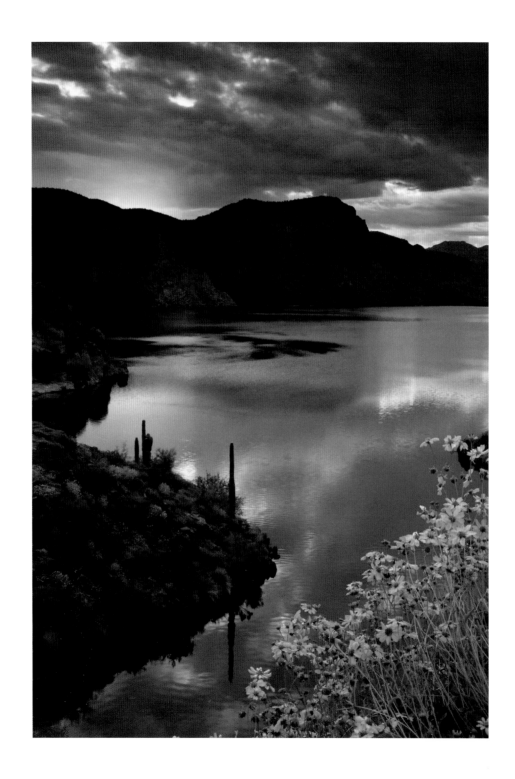

GEORGE STOCKING

MARCH 2011
DIGITAL
CANYON LAKE

The dramatic quality of light in this photograph is one of the things that impressed us most. The flowers in the lower right of the frame almost feel like they were glued to the photograph as part of a collage. There are lines that lead you back to the sunset, and the lake reflects a blue sky. The myriad colors are wonderful and ideal. There's a painterly quality to them.

"I was running out of light by the time I made it to Canyon Lake, so I decided to return to an inlet I had scouted earlier. I was pleasantly surprised to see brittlebush, and the sky looked like the Fourth of July."

— GEORGE STOCKING

PAUL GILL

MARCH 2011
DIGITAL
BARTLETT LAKE

It's the surprise in this photograph — the reflections of the saguaros in the water droplets — that made it stand out from the thousands of other flower images we've published. Paul Gill was a graphic designer before he became a photographer, so he sees patterns and design very well. He shot this as part of a series, using a macro lens that's very difficult to work with. He filled the frame with the poppy, but it's out of focus, because he's focusing on the droplets.

"You really can't see that image unless you're looking through that lens and crawling through the dirt. It's one of those photos you can't walk into and make. You have to find it."

— PAUL GILL

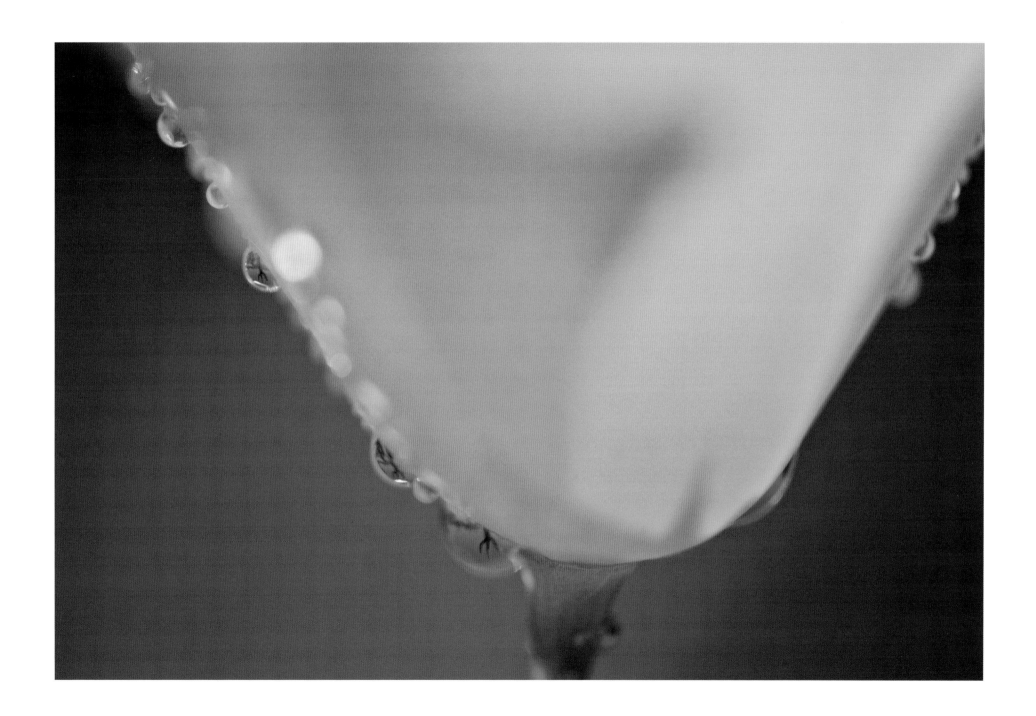

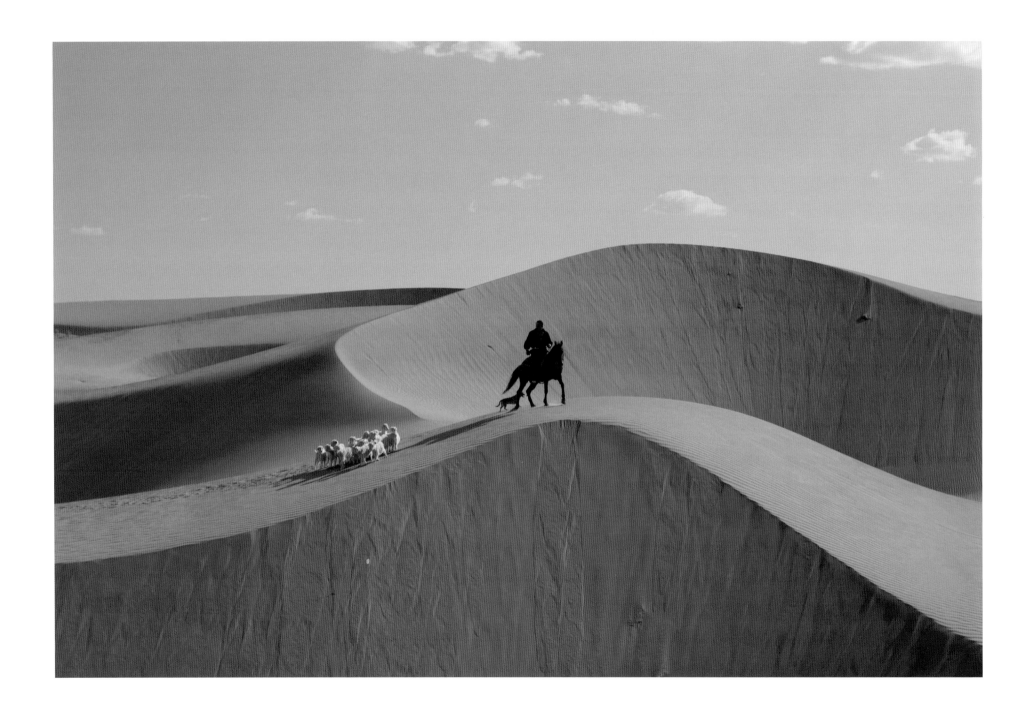

SUZANNE MATHIA

AUGUST 2011
DIGITAL
CANYON DE CHELLY

This photo is wonderful because of the contrast between the cool blue sky and the coral tones of the sand. Sand dunes have an inherent beauty, but without the rider and sheep, the photo wouldn't have the same context and meaning. Would it be beautiful? Yes. But with them in it, the photo has a sense of purpose.

"Sand dunes are one of my favorite subjects to photograph — I can capture the shape of the wind. The dunes are ever-changing, growing and cresting like a relentless red tide."

— SUZANNE MATHIA

NICK BEREZENKO

AUGUST 2011
35 MM FILM
POTATO LAKE

It's hard to differentiate this photograph from a painting. Magical and graceful, it has a Monet quality about it. The 19th century impressionists were fascinated with light — they talked about light and quality of light — and that's exactly what Nick Berezenko saw here. The soft breeze created those ripples, and the upper canopy of the aspens reflects in the water. Berezenko shot the photograph horizontally, so it has space and breathability.

"I've always loved the impressionist painters, and I've always been fascinated with photographing water. Its liquidity, translucence and reflective properties allow me to photographically come close to that impressionistic ideal more than any other subject."

— NICK BEREZENKO

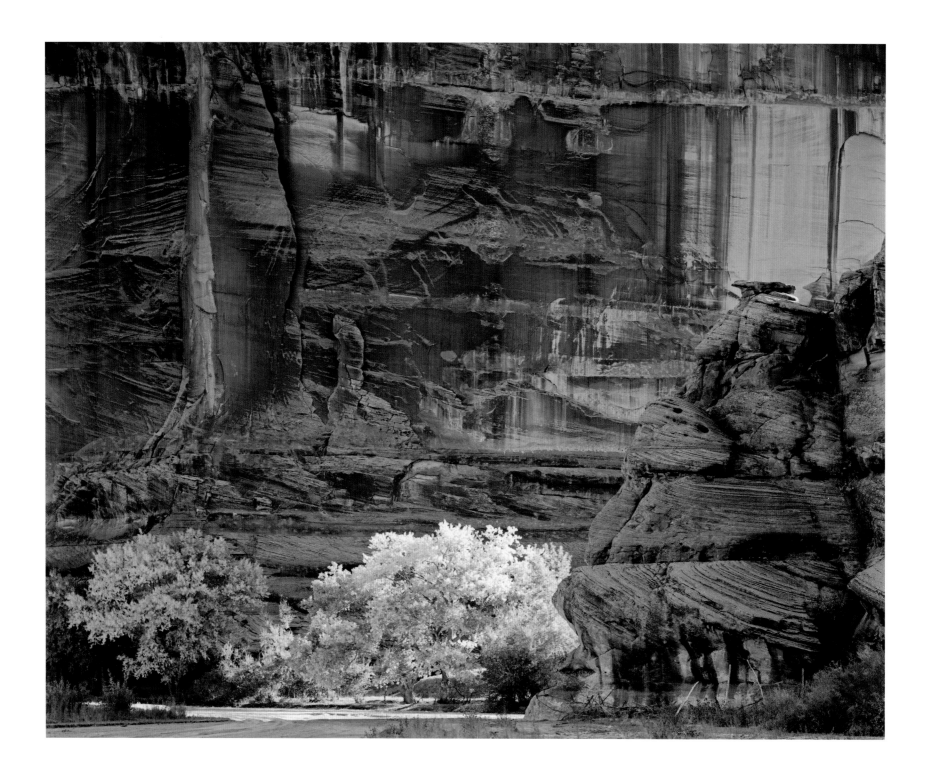

JAY DUSARD

SEPTEMBER 2011
4x5" FILM
CANYON DEL MUERTO

We selected this photograph for its textures and the quality of light on the tree. Jay Dusard made the image with a 4x5 view camera, and it's absolutely exquisite. You can see the swirling forms on the rocks. The frame leads your eye to the brilliantly lit cottonwood that takes center stage in the shot.

"There was this beautiful shaft of early morning light coming straight down a narrow side canyon, illuminating those cottonwood trees."

— JAY DUSARD

LAURA GILPIN

SEPTEMBER 2011
4x5" FILM
NAVAJO INDIAN RESERVATION

The richness of this documentary photograph comes through in the smallest of details. This is a moment frozen in time. The subject is positioned to the side, and you can see his tools. Look at the position of his hands. You're given little hints about who this man might be. His shirt is tattered; he has holes in his pants. Photographs like this leave just enough breadcrumbs to tell a story.

"The romance of the Old West vanished so fast, and so few ever did anything with it. Does it make you realize the importance of art and how the main knowledge of history is through art alone?"

— LAURA GILPIN

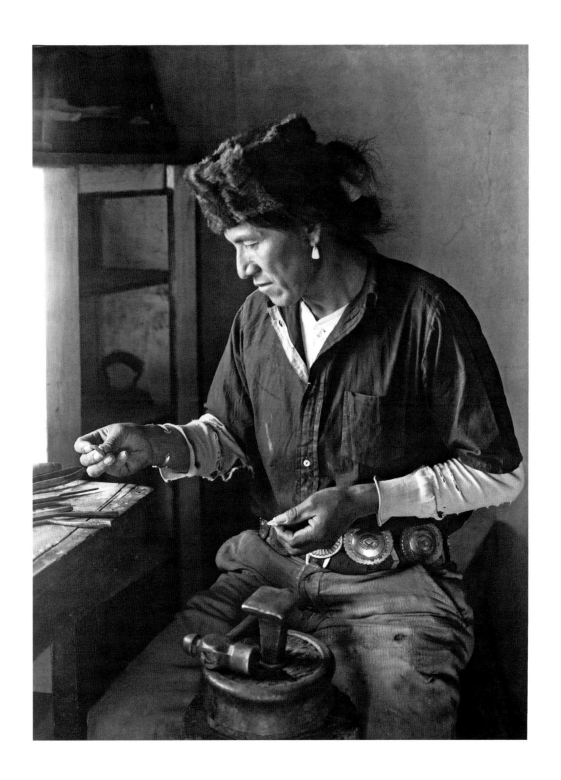

DAVID MUENCH

MAY 2012
4x5" FILM
WHITE MOUNTAINS

David Muench brilliantly captured a sense of adventure in this photograph. There is so much going on in the image, and yet everything is in its place. There's a plot here, an aspect of discovery just waiting to be uncovered.

"I had visualized this idea of the sun coming through the trees — I wanted just enough sun peeking out from behind the trees to create an interesting photograph, but not too much where I'd have a big, unattractive flare."

— DAVID MUENCH

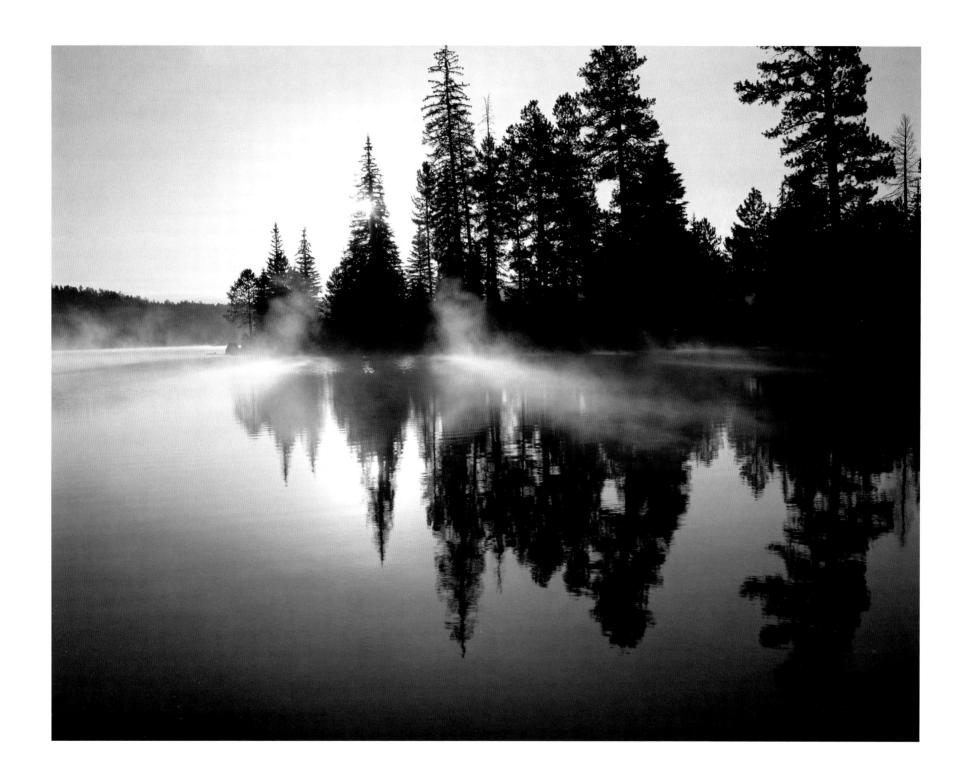

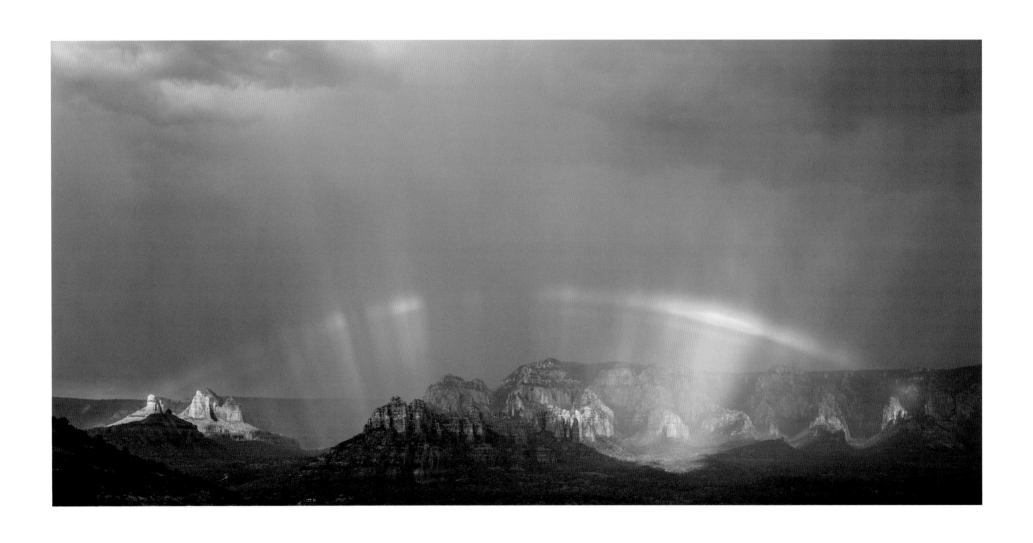

MARK FRANK

JUNE 2012
DIGITAL
SEDONA

We couldn't take our eyes off the rainbow in this photograph. You have to put yourself in a position to capture something like this, and that's exactly what Mark Frank did. He found his place, and he worked it. It's about familiarity. It's about patience. You have to believe something is going to happen. Frank took a chance, he rolled the dice and he won.

"When I arrived on the loop trail, the sky above the rim was gray. The dramatic spotlights on Mitten Ridge and Munds Mountain, and the light shafts coming through the rainbow, make this image."

— MARK FRANK

GARY LADD

JULY 2012
35 MM FILM
COLORADO RIVER

This is Hemingway — man versus nature. You can see that these people are out in the elements, and yet, there's something very peaceful about it. You also don't often see people in an old-school wooden dory on the Colorado River, and that adds to this image's appeal.

"It was one of those extraordinarily delicate moments that passes so quickly — it seems unlikely to capture such a scene in a photo."

— GARY LADD

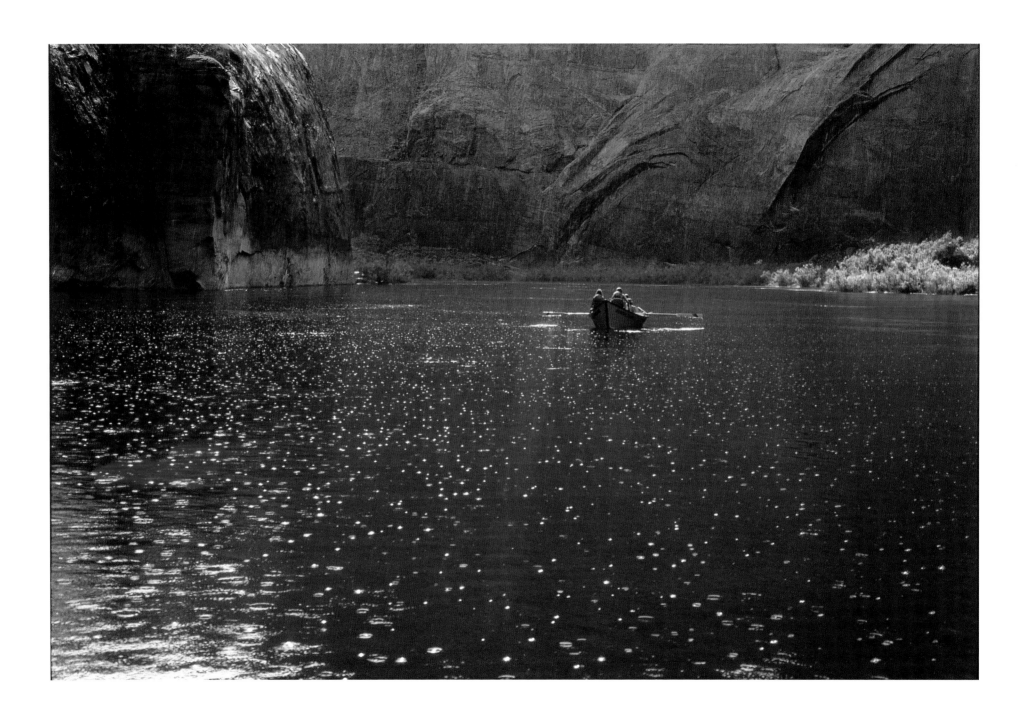

GEORGE STOCKING

AUGUST 2012
DIGITAL
GRAND CANYON

At the end of the day, perseverance separates a good photographer from a great one. George Stocking talked about weathering different storms and how hard he worked just moving his gear in and out of his car to avoid lightning strikes. Stocking did what it took to capture this powerful image of the Grand Canyon because he believed there was the potential for magic.

"The 'double layered sunset,' as I have named it, is where clouds at various altitude levels turn different colors."

— GEORGE STOCKING

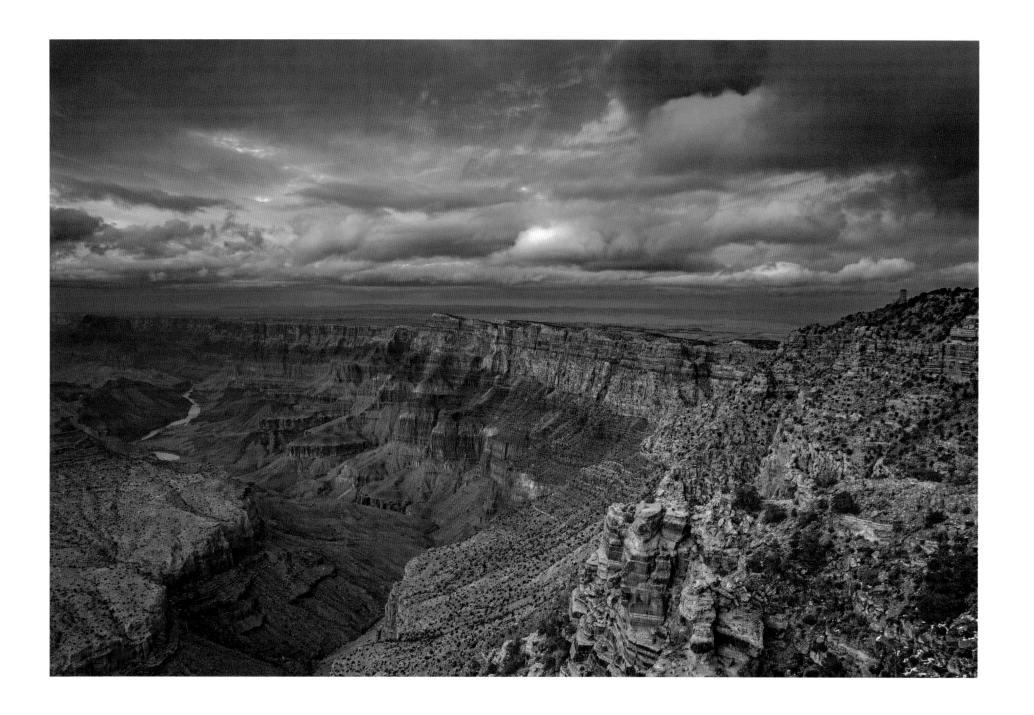

This book was printed on 105-pound GoldEast matte art paper on a sheet-fed press,
with 95-pound Woodfree end papers. It was imaged directly to plates at 2,400 dpi, with halftones rendered
using a 133-line screen (for Woodfree) and 175-line screen (for coated paper) with round dots
angled at 15° (black channel). The book jacket is 105-pound gloss art paper
with matte lamination. The font in this book is Helvetica.